vatos

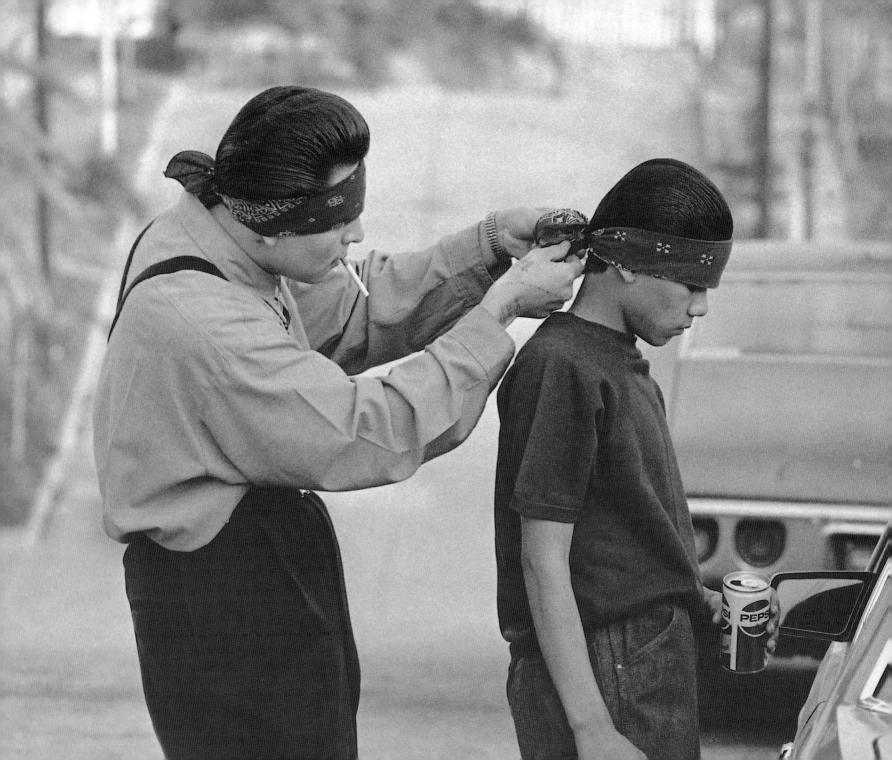

vatos

photographs by José Galvez

poem by Luis Alberto Urrea

Jose Galvez (signature)

CINCO PUNTOS PRESS • EL PASO, TEXAS

foreword

BY BENJAMIN ALIRE SÁENZ

The Language the World Has Made Me Forget

IT IS ALMOST DUSK, and I have wandered into a forgotten neighborhood. I see a face, dark, indigenous—then turn away. I see another man walk past me—thin, self-possessed. As I watch his graceful strut that is at once studied and natural, I think he might have become a dancer—but he was born in a barrio, born too Mexican and too poor and I don't want to think about the complicated history of the world. Across the street, an old man, his back bent from years of work, emerges from the comforting anonymity of the city. He reminds me of my grandfather who is dead. No amount of thinking will bring him back to life.

A man walking toward me, stops, lights a cigarette. Our eyes meet for an instant, and a moment of knowledge passes between us: *I know you, I know everything about you*, and this moment becomes a moment of suspicion and this moment of suspicion becomes a moment of hatred. *I know you. I know everything about you.* Our eyes are little more than weapons. We have convinced each other that nothing can exist between us except war. I have been taught that he and I have nothing in common. But I knew him once. He looks just like my brother. I have had to forget him in order to survive. And so we live in different countries.

I keep moving down the street. I watch another dark man walking in front of me—he carries his ancestors in his eyes, on his face, in his proud walk. He disappears down the street, disappears into the crowd, back into the city. He is invisible again. He cannot hurt me.

But then the photographs here and the words of this poem intervene. The camera and the rhythms of the language stop the world from moving.

I turn the page, and there are the men I saw on the street, forever frozen, forever confronting—forever accusing me. I have learned to think of them as enemies, objects of fear, of archaic masculinity. But now, as I stare into their eyes, they become as familiar to me as my boyhood. I begin to see their poverty, begin to remember my own. I begin to wonder about the houses they live in, the barrios that gave them life, the women who love them, the mothers who lost them to the seductions of the street. I begin to understand their wounds, and I find myself growing angry at those outside the picture, those who've forced them into segregated neighborhoods, forced them into fighting a war they did not choose to fight, forced them to become warriors when they would have chosen more peaceful vocations. I begin to see that they are hunted and wounded and hated and I wonder how they bear such burdens. It is not so difficult to see their hearts, and

Vatos—street slang for dude, guy, pal, brother—sprang from the highly stylized language of the Pachucos (*los chukotes*) in the '50s. It's a Chicano term derived from the once-common friendly insult *chivato*, or goat. It had a slightly unacceptable air to it, which the *Locos* and *Weesas* of the Chuco world enjoyed. They were able to take the sting out of racism by calling themselves a bunch of names assimilated "good Mexicans" didn't like. —Luis Urrea

I begin to imagine the rooms where they spend their days, the children they dream of having, the ordinary peace they yearn for.

I cannot turn away from this book—and I thank God for this small and miraculous intervention. These men, there are thousands of them. There are millions. As I stare at these brave and arrogant and beautiful men, I make a silent promise to myself that the next time I walk down a street, I will stop one of them and ask him to tell me the word for brother in the language the world has made me forget.

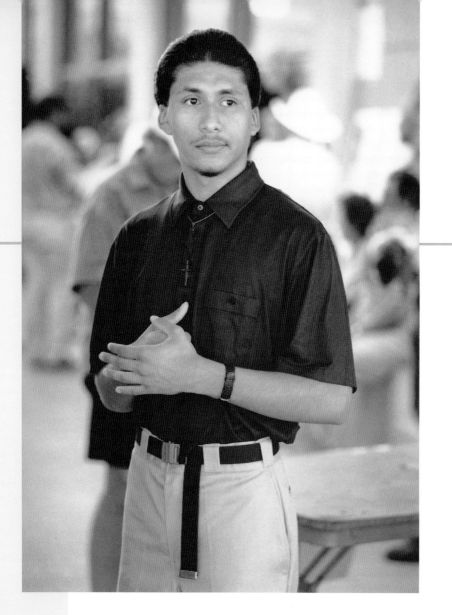

hymn to vatos who will never be in a poem

by Luis Alberto Urrea

All the vatos sleeping in the hillsides
All the vatos say goodnight forever
All the vatos loving their menudo
All the vatos faith in la tortilla
All the vatos fearing the alarm clock
All the vatos Wino Jefe Peewee
All the vatos even the cabrones
All the vatos down por vida homeboys
All the vatos using words like ranfla
All the vatos who woke up abandoned
All the vatos not afraid of daughters
All the vatos arms around their sisters
All the vatos talking to their women
All the vatos granting their forgiveness
All the vatos plotting wicked paybacks
All the vatos sleeping under mota

All the vatos with tequila visions
All the vatos they call maricones
All the vatos bleeding in the alley
All the vatos chased by helicopters
All the vatos dissed by pinches white boys
All the vatos bent to pick tomatoes
All the vatos smoked by Agent Orange
All the vatos brave in deadly classrooms
All the vatos pacing in the prisons
All the vatos pierced by needle lightning
All the vatos who were once our fathers
All the vatos even veteranos
All the vatos and their abuelitos
All the vatos proud of tatuajes
All the vatos carrying a lunch pail
All the vatos graduating law school
All the vatos grown up to be curas
All the vatos never been to misa
All the vatos Jimmy Spider Tito
All the vatos lost their tongues in Spanish
All the vatos can't say shit in English
All the vatos looking at her photo
All the vatos making love till morning

All the vatos stroking their own hunger
All the vatos faded clear as windows
All the vatos needing something better
All the vatos bold in strange horizons
All the vatos waiting for tomorrow
All the vatos sure that no one loves them
All the vatos sure that no one sees them
All the vatos sure that no one hears them
All the vatos never in a poem
All the vatos told they don't belong here
All the vatos beautiful young Aztecs
All the vatos warrior Apaches
All the vatos sons of Guadalupe
All the vatos bad as la chingada
All the vatos call themselves Chicanos
All the vatos praying for their children
All the vatos even all you feos
All the vatos filled with life eternal
All the vatos sacred as the Sun God
All the vatos Flaco Pepe Gordo
All the vatos rising from their mothers

All you vatos, you are not forgotten.

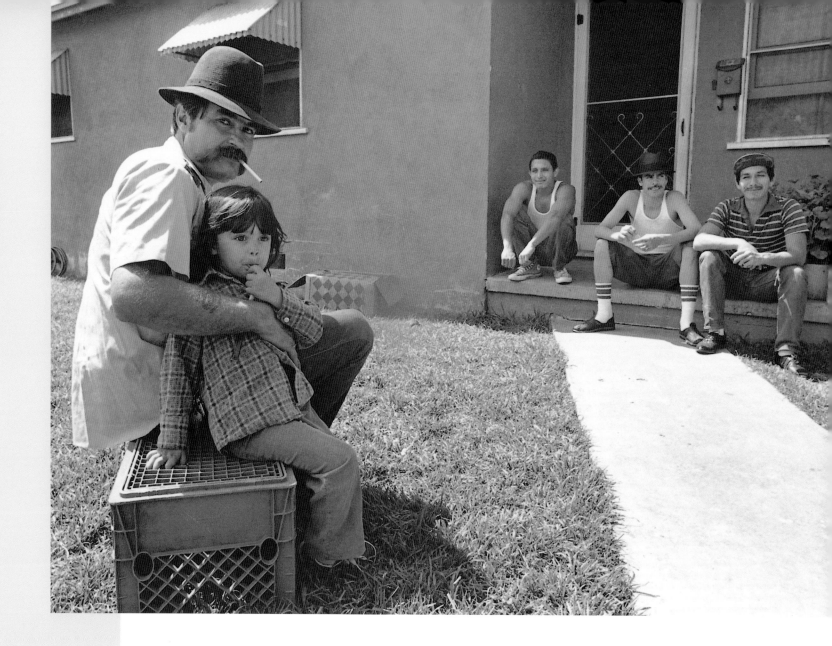

vatos

PARA mi linda ruca, que comenzó la idea para el libro.
Gracias, mi amor.
—JOSÉ GALVEZ

FOR all the vatos—here and gone.
—LUIS ALBERTO URREA

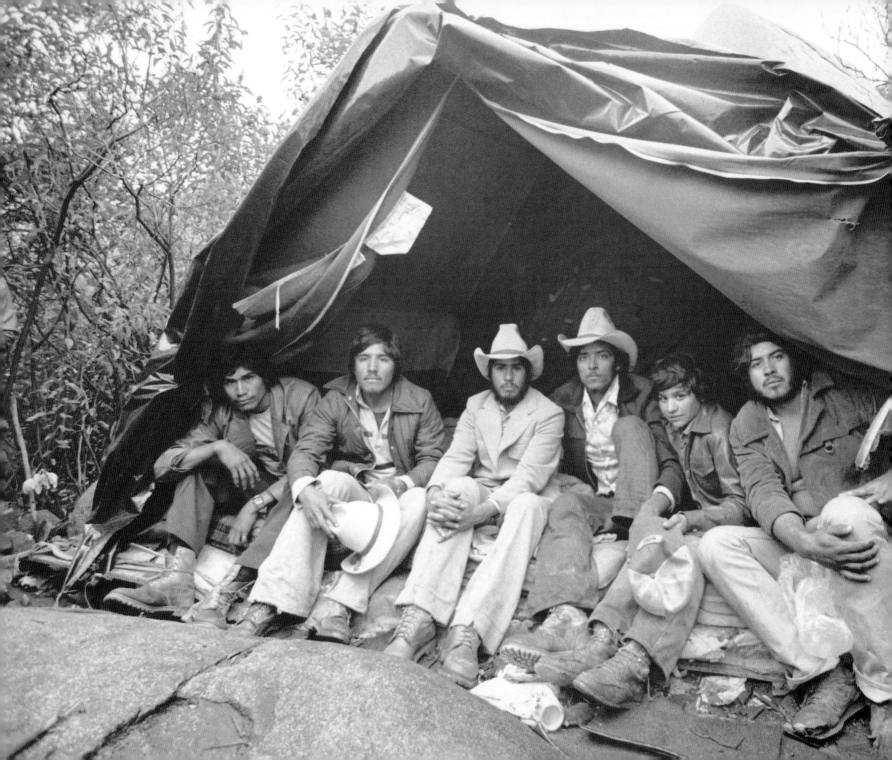

All the vatos sleeping in the hillsides

All the vatos say goodnight forever

All the vatos loving their menudo

All the vatos faith in la tortilla

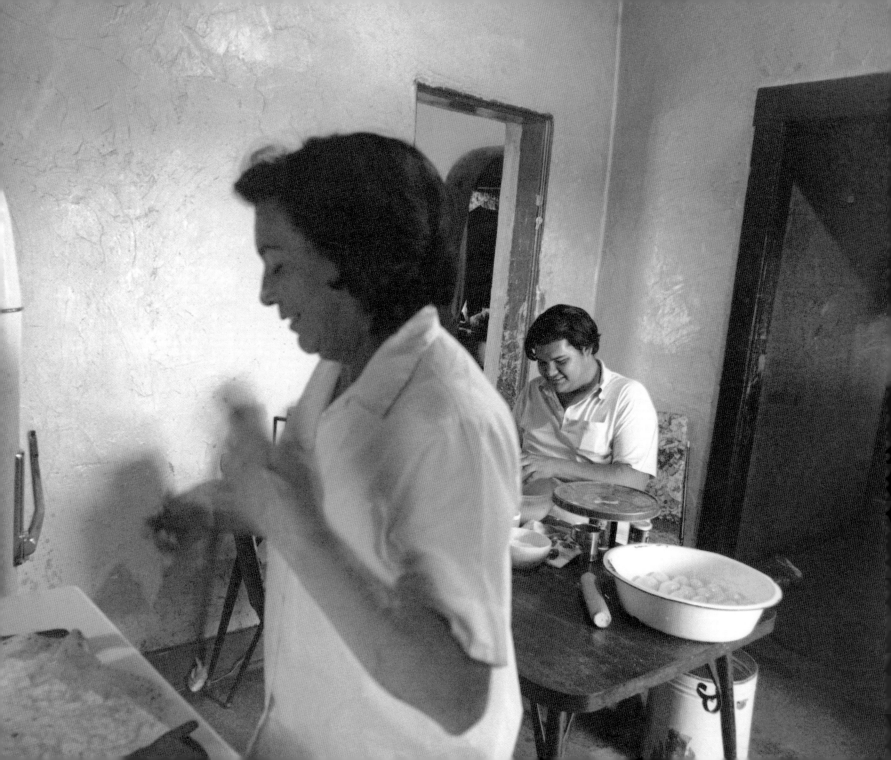

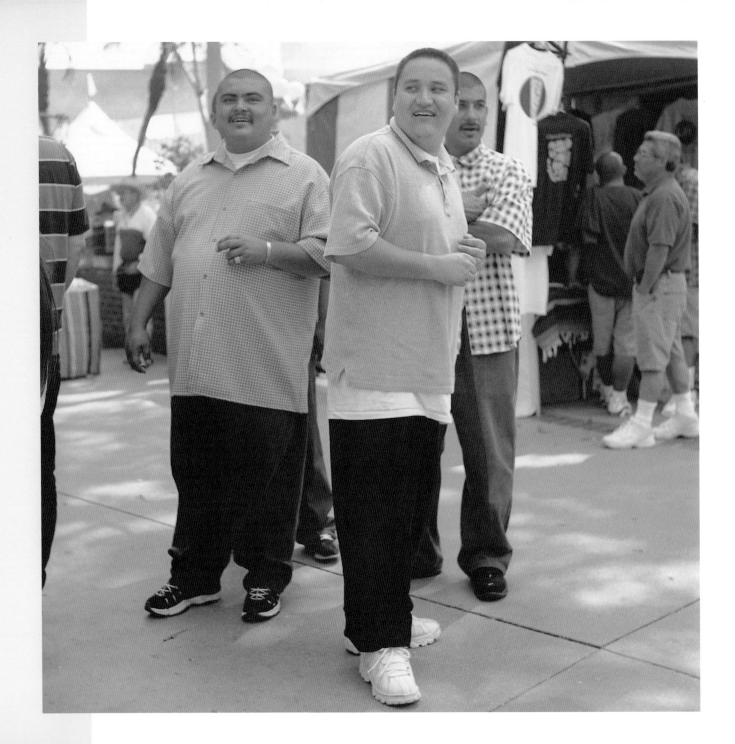

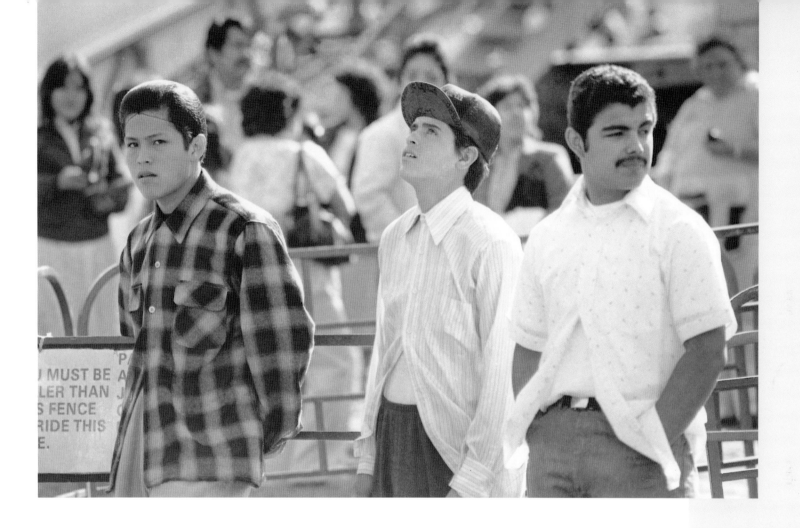

All the vatos fearing the alarm clock

All the vatos Wino Jefe Peewee

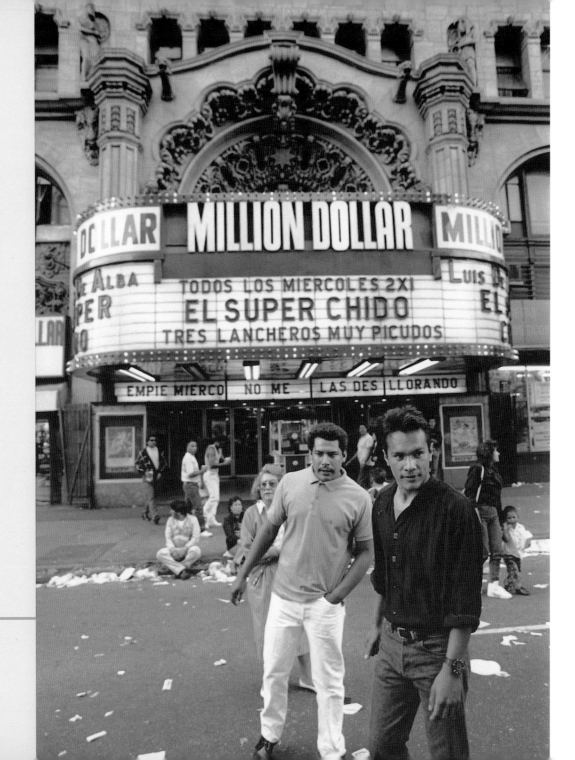

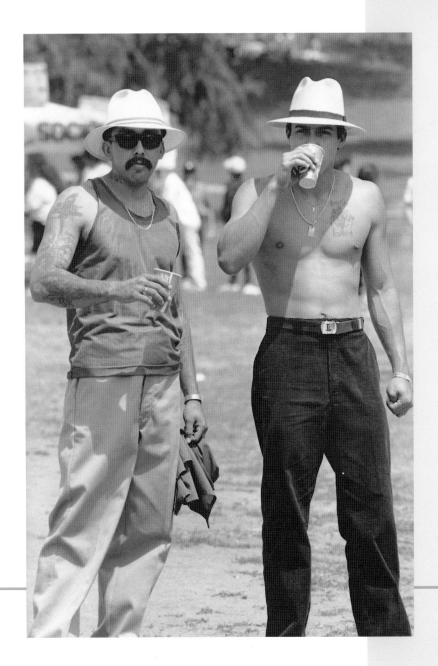

All the vatos even the cabrones

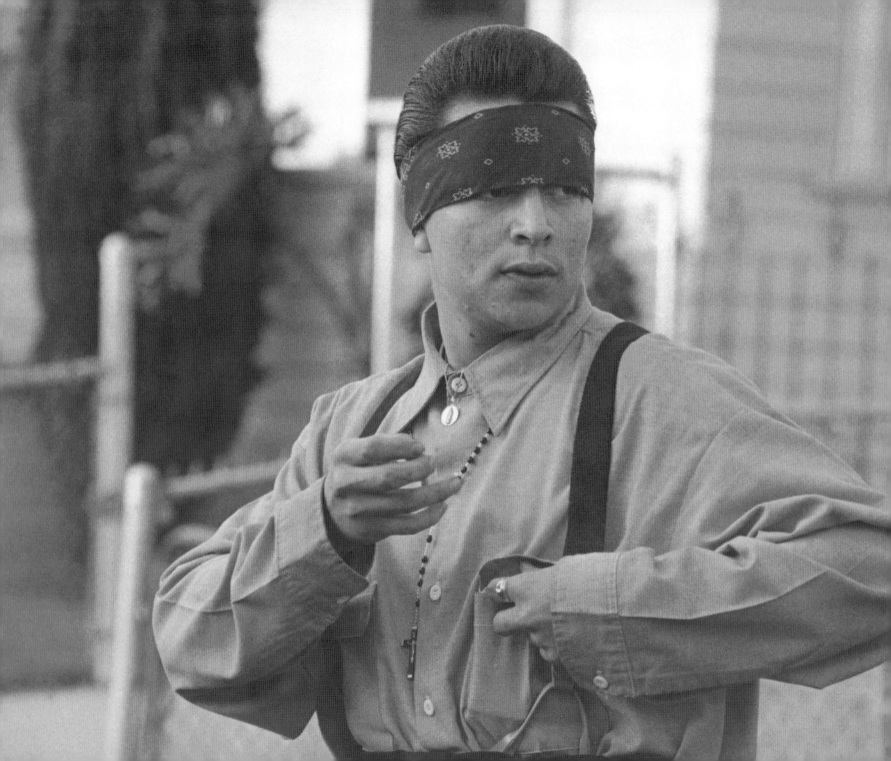

All the vatos down por vida homeboys

Raul (Yogie) Alaniz 1983

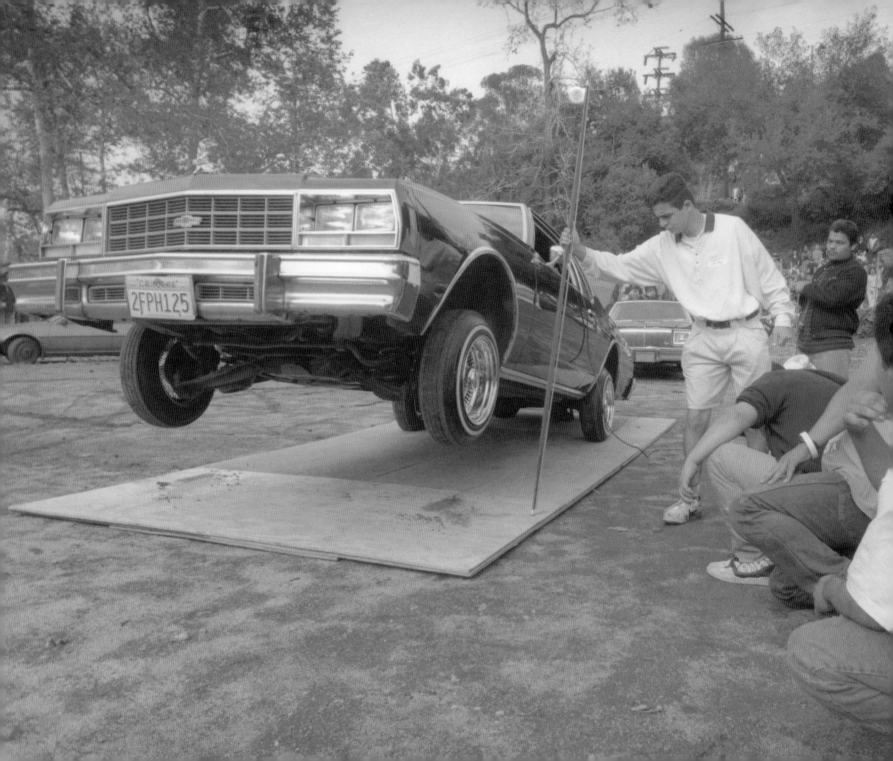

All the vatos using words like ranfla

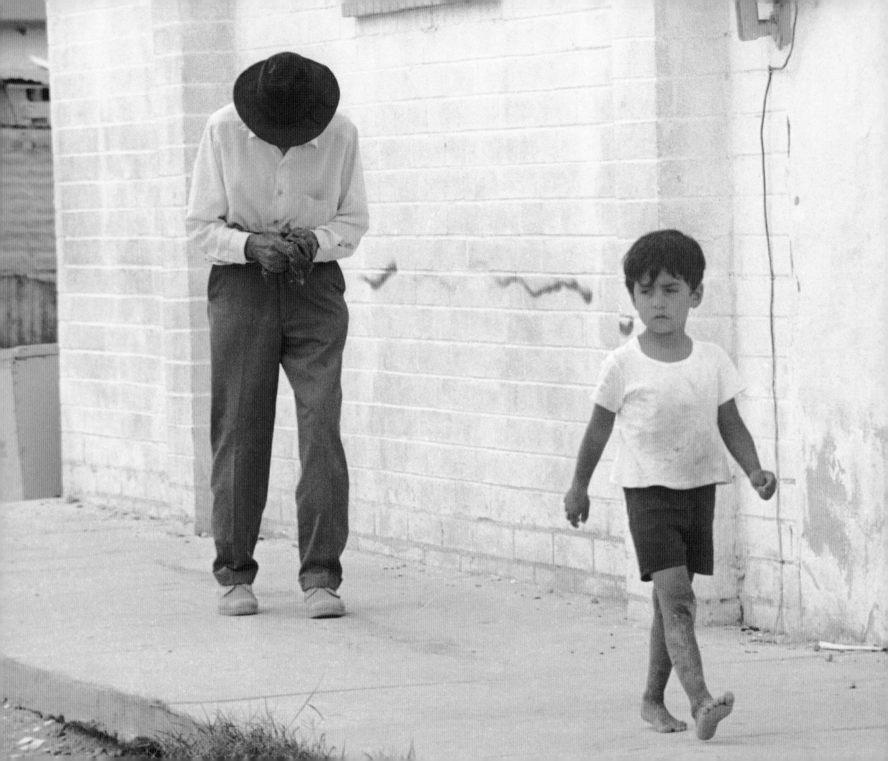

All the vatos who woke up abandoned

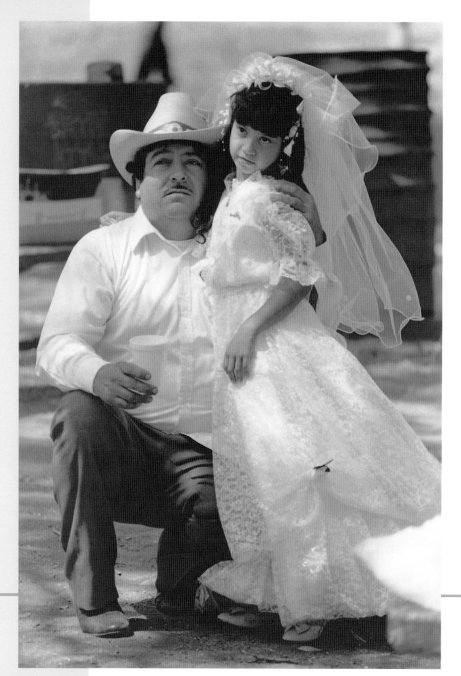

All the vatos not afraid of daughters

All the vatos arms around their sisters

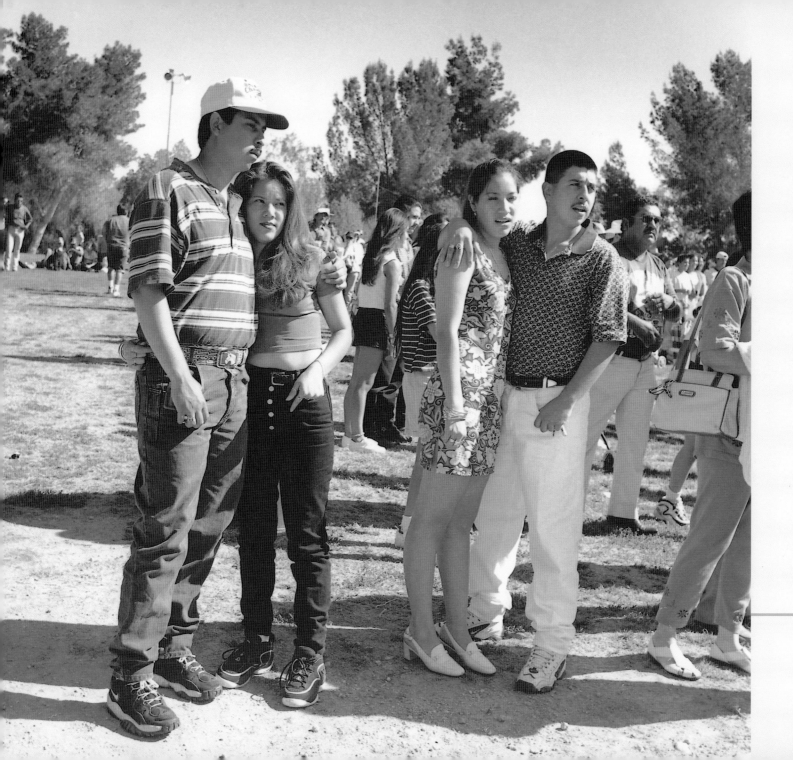

All the vatos talking to their women

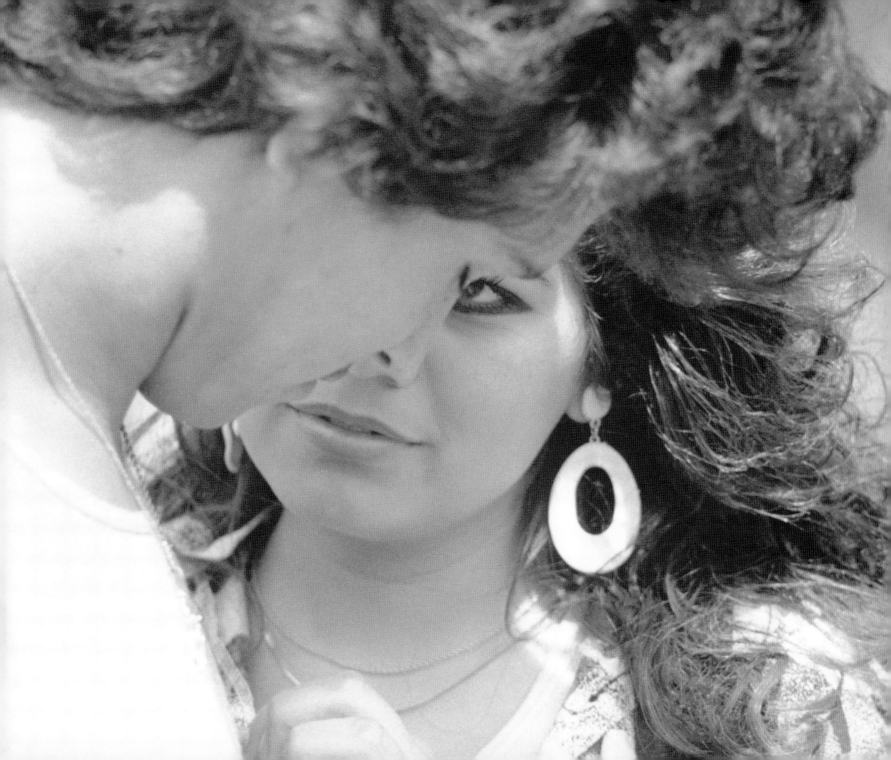

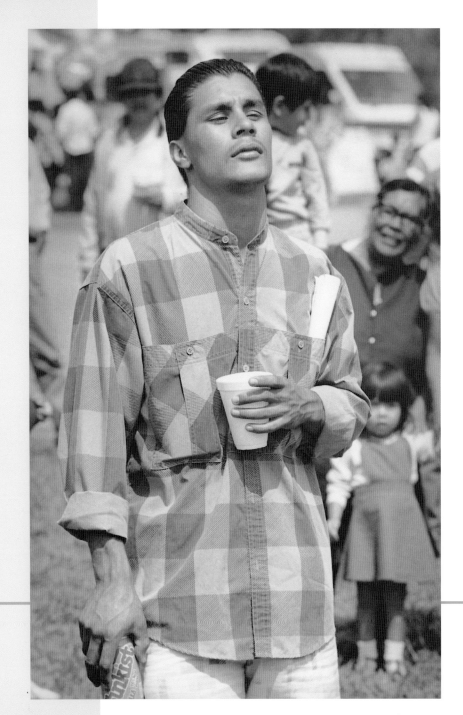

All the vatos granting their forgiveness

All the vatos plotting wicked paybacks

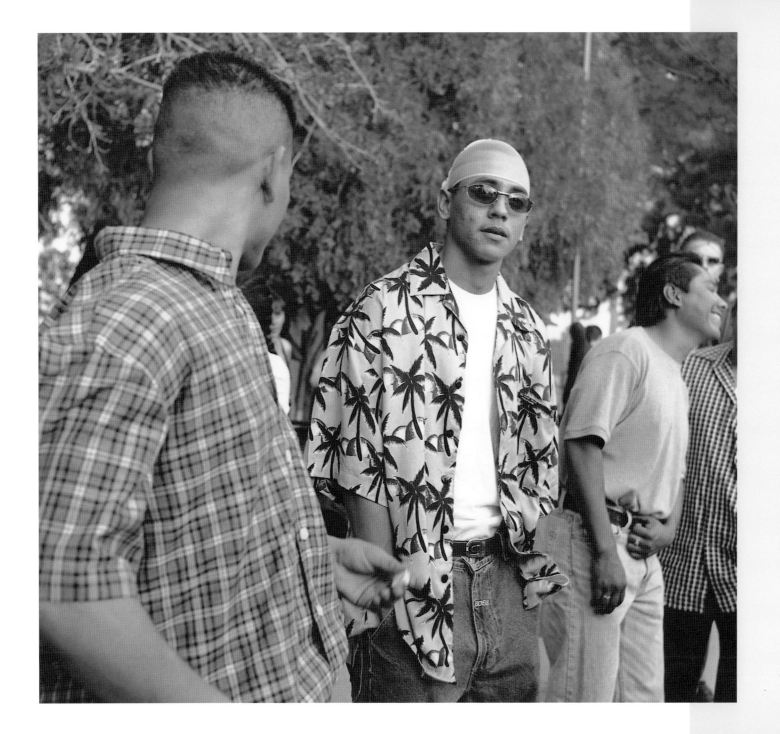

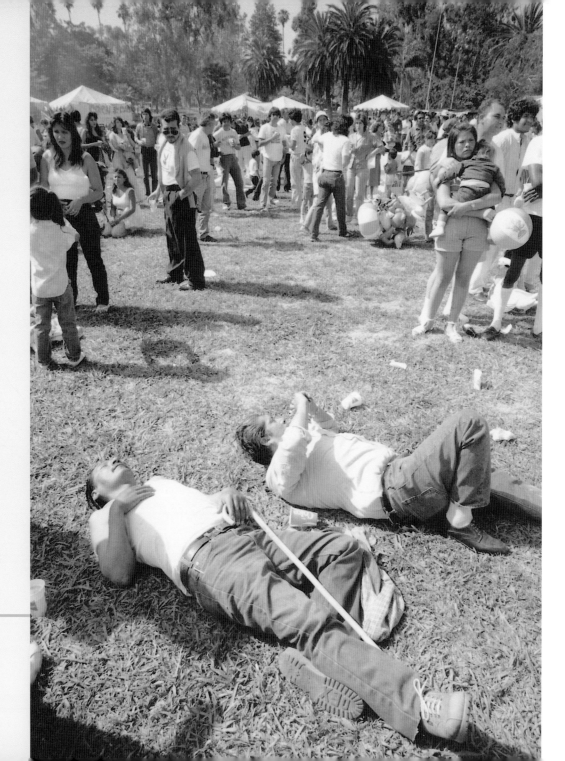

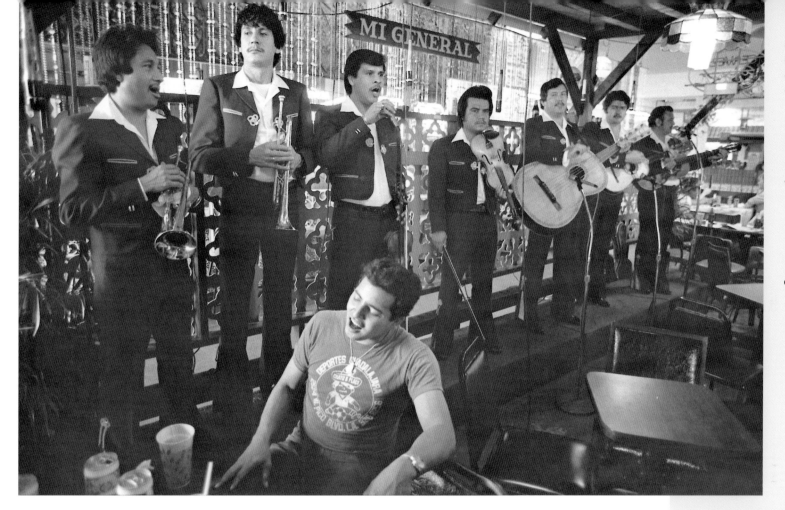

All the vatos sleeping under mota

All the vatos with tequila visions

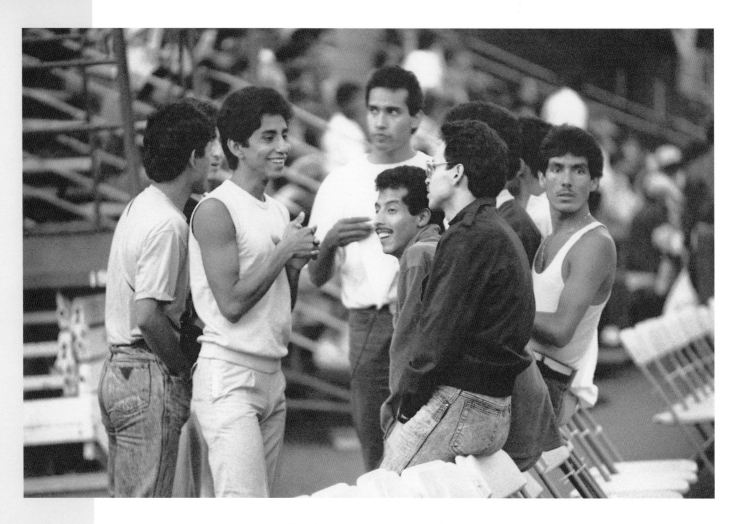

All the vatos they call maricones

All the vatos bleeding in the alley

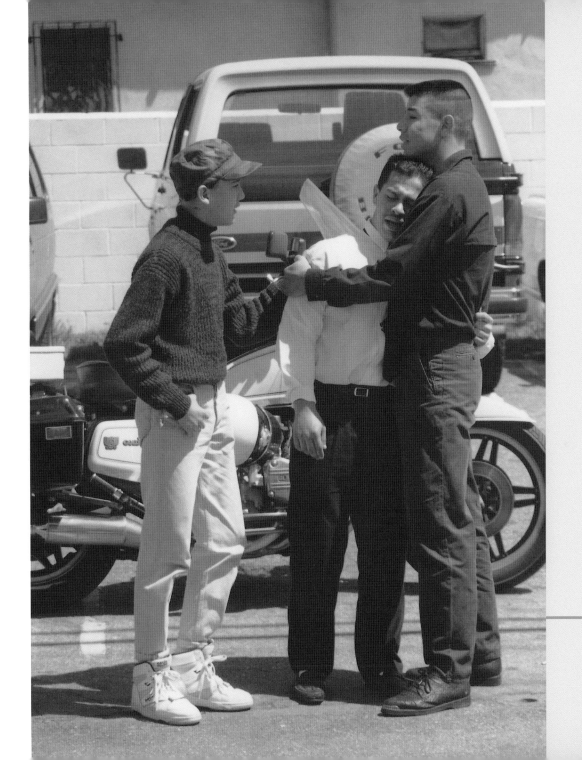

All the vatos chased by helicopters

All the vatos dissed by pinches white boys

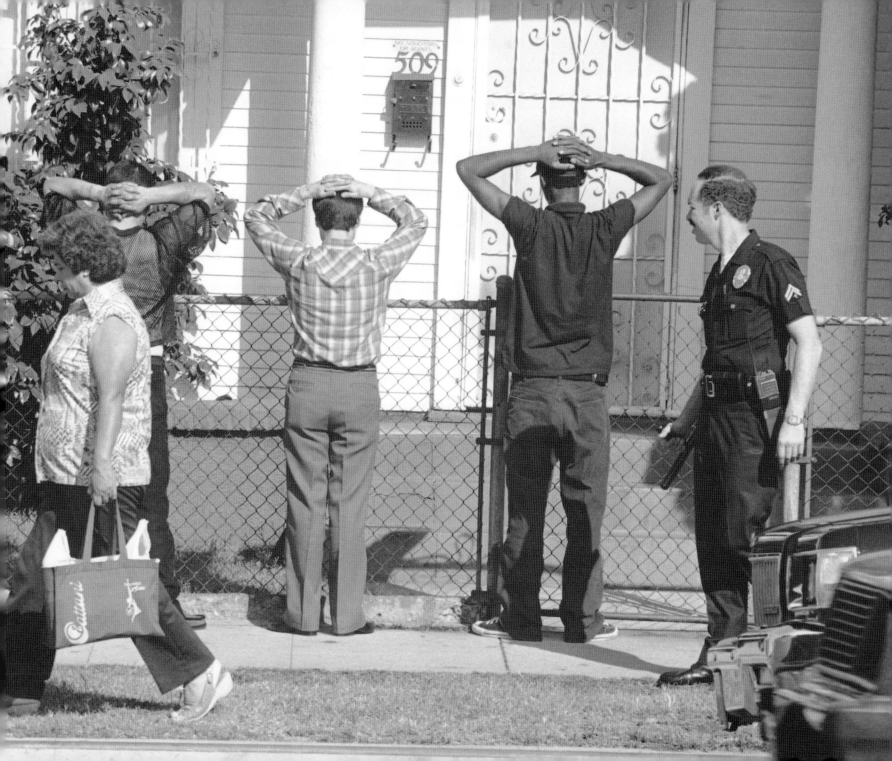

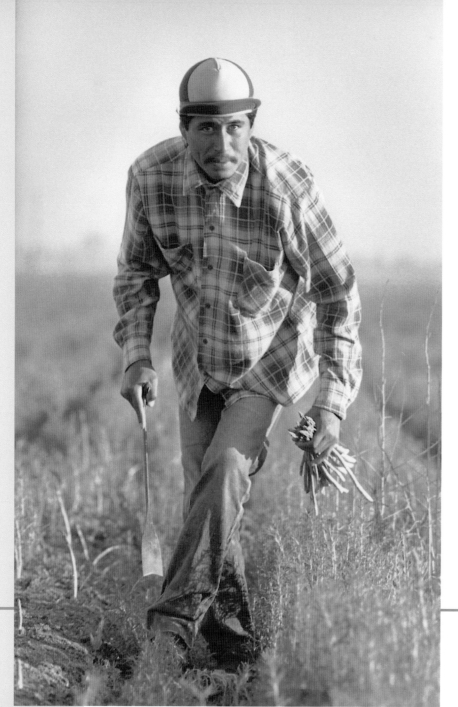

All the vatos bent to pick tomatoes

All the vatos smoked by Agent Orange

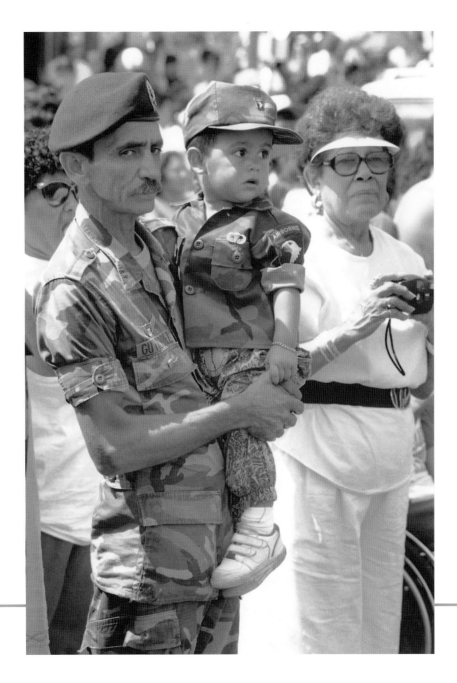

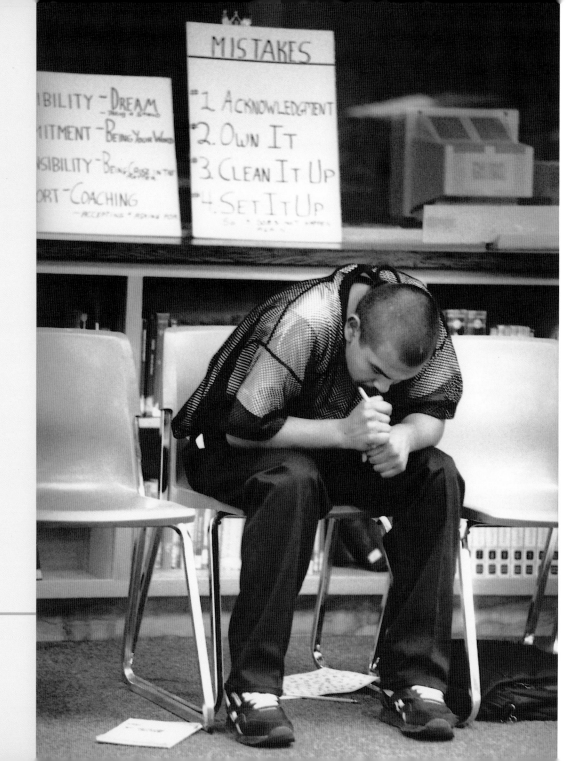

All the vatos brave in deadly classrooms

All the vatos pacing in the prisons

All the vatos pierced by needle lightning

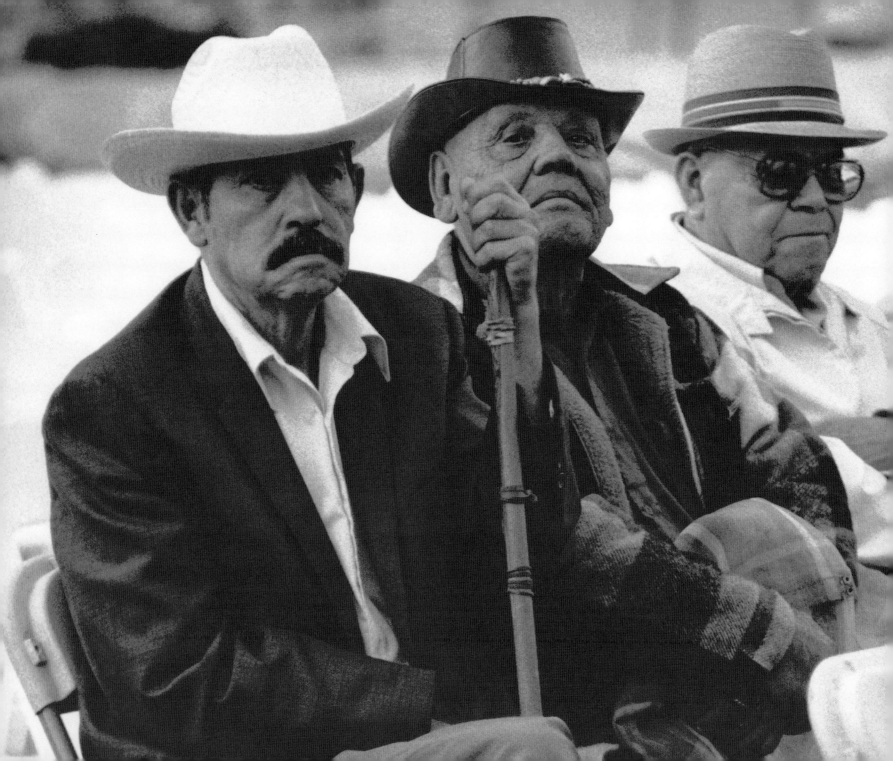

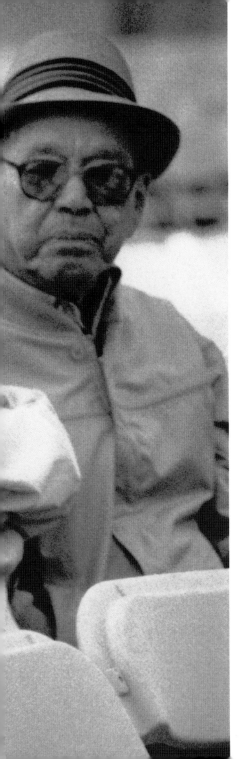

All the vatos who were once our fathers

All the vatos even veteranos

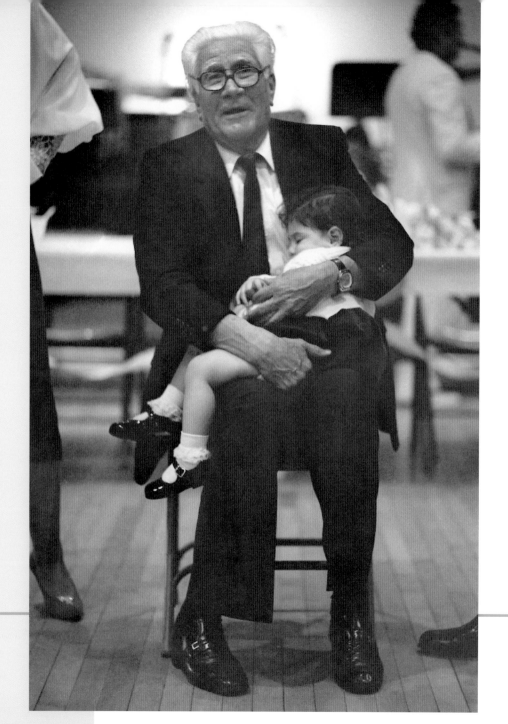

All the vatos and their abuelitos

All the vatos proud of tatuajes

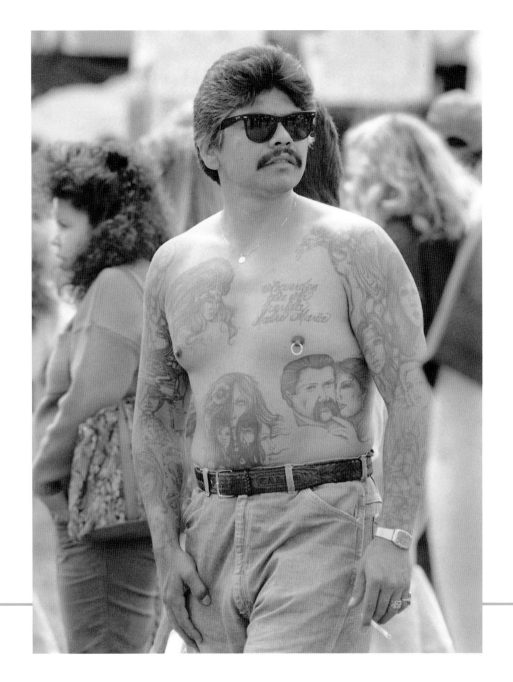

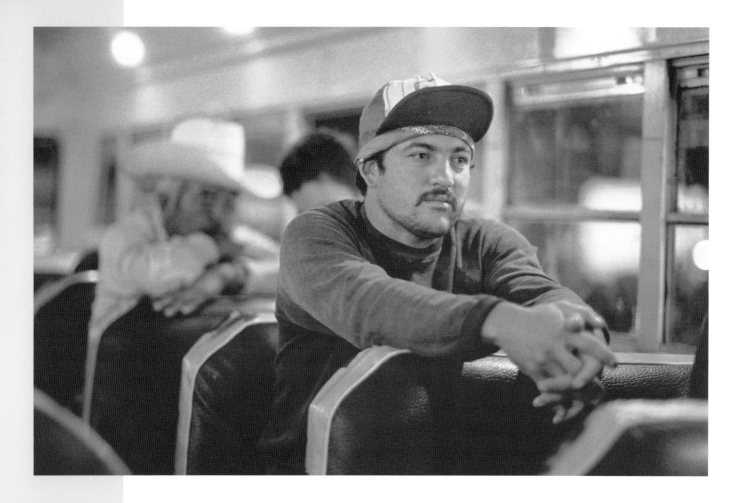

All the vatos carrying a lunch pail

All the vatos graduating law school

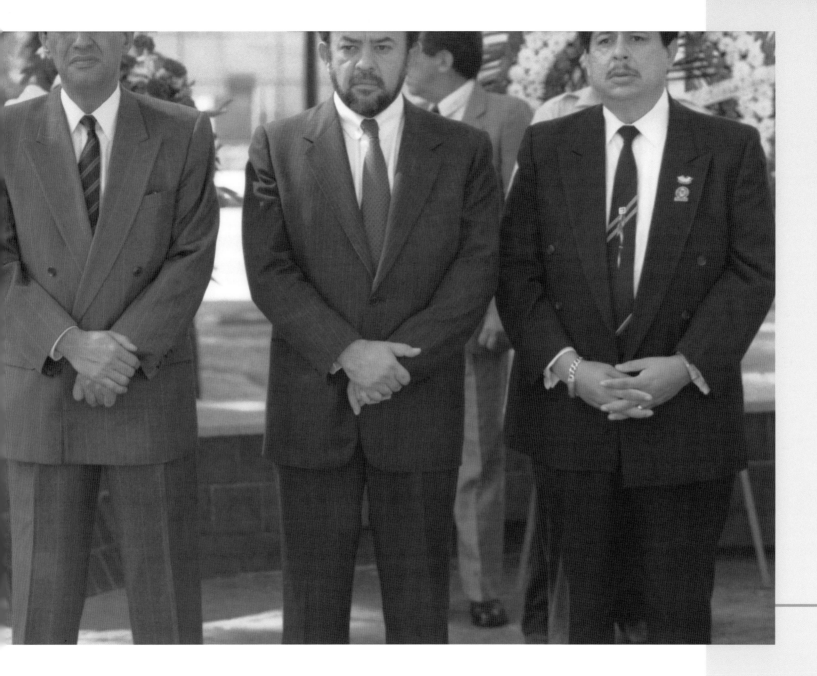

All the vatos grown up to be curas

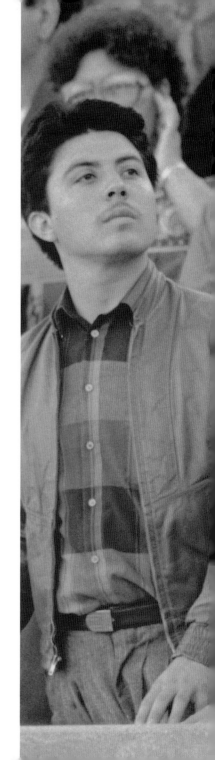

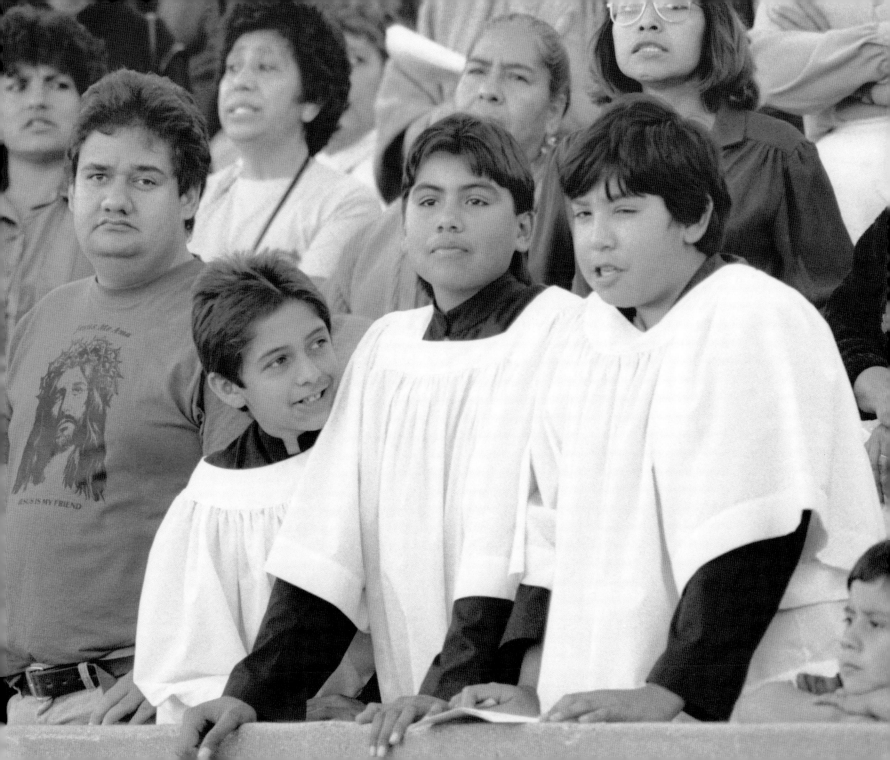

All the vatos never been to misa

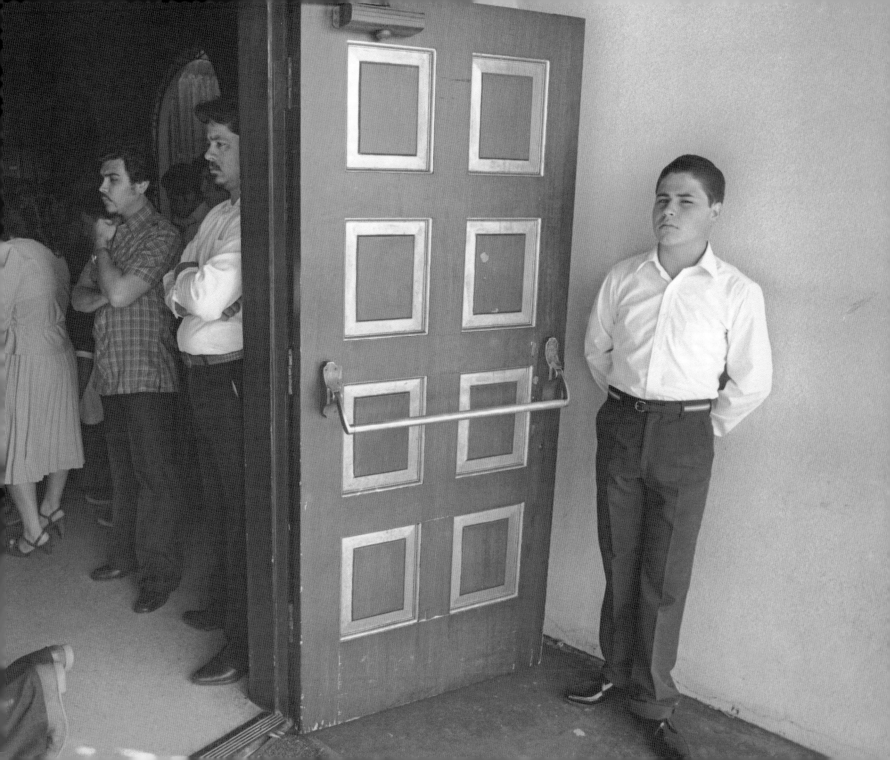

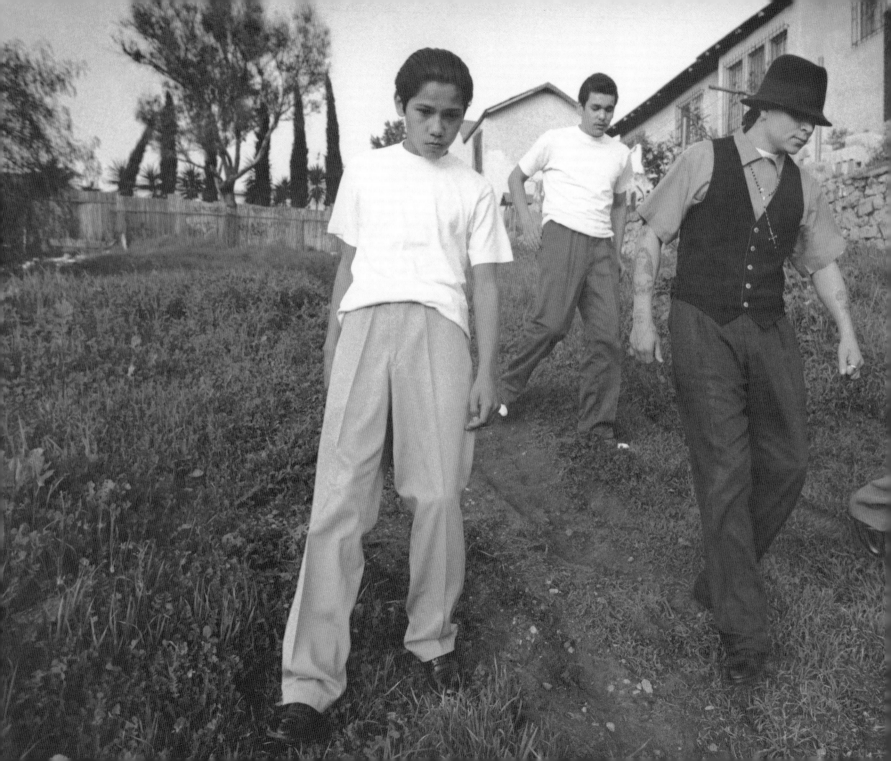

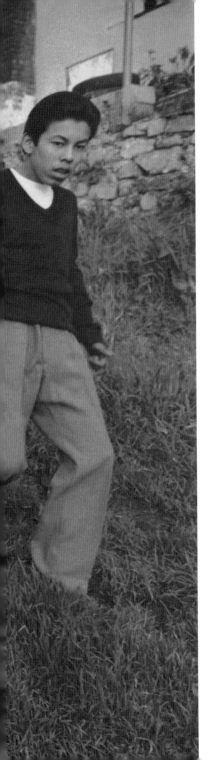

All the vatos Jimmy Spider Tito

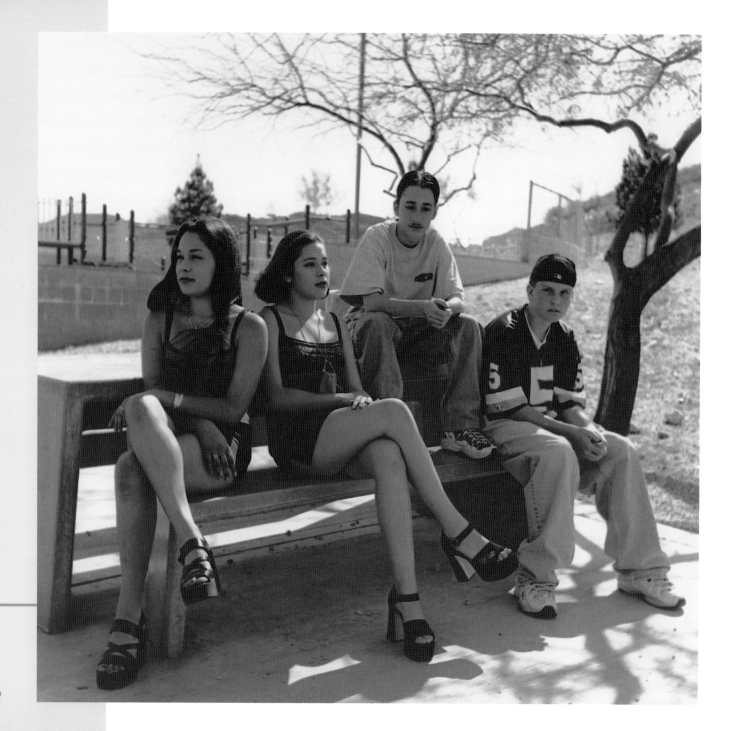

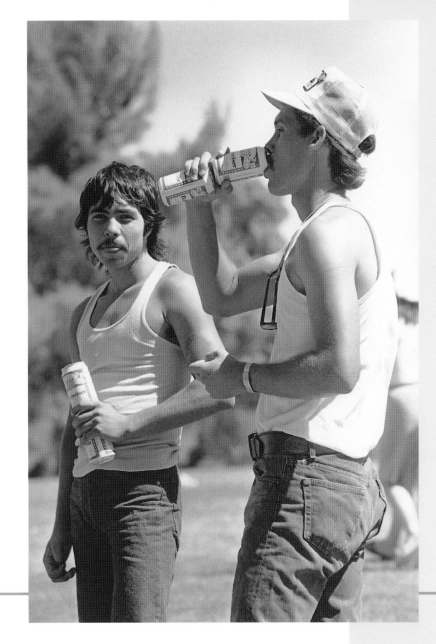

All the vatos lost their tongues in Spanish

All the vatos can't say shit in English

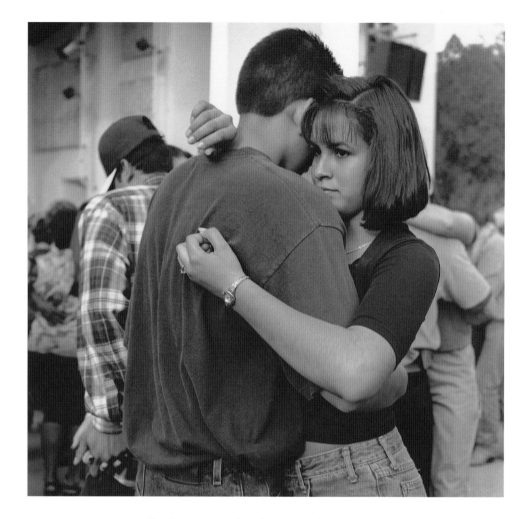

All the vatos looking at her photo

All the vatos making love till morning

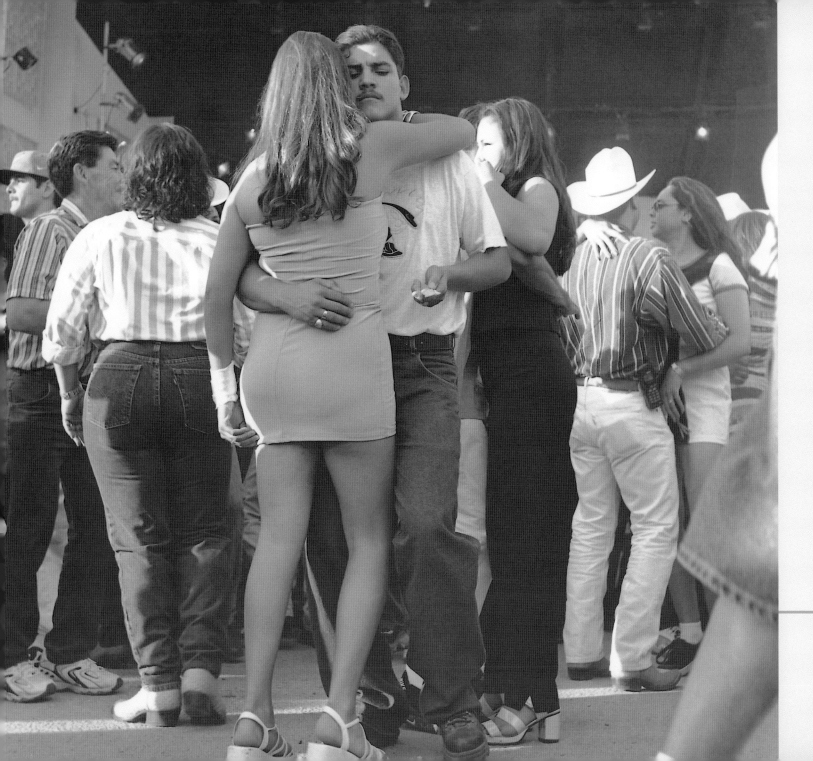

All the vatos stroking their own hunger

All the vatos faded clear as windows

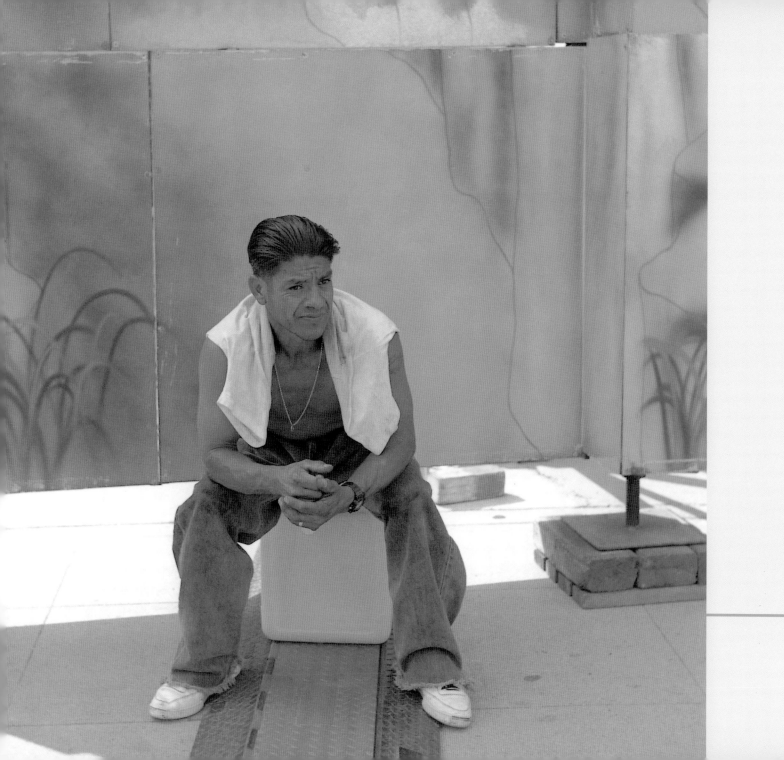

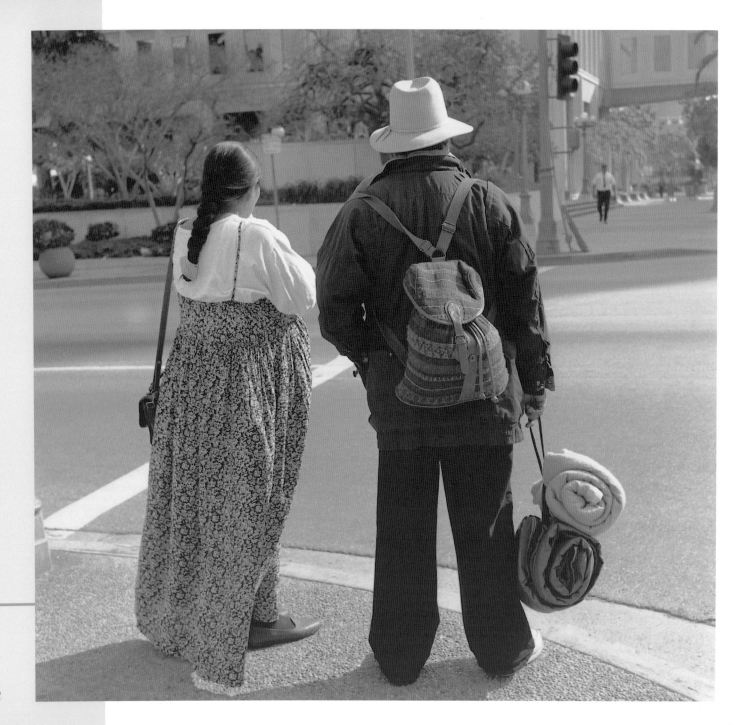

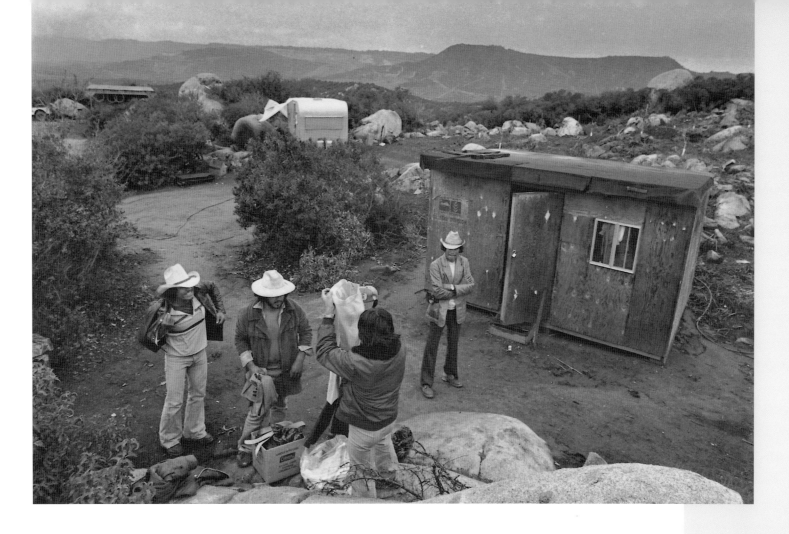

All the vatos needing something better

All the vatos bold in strange horizons

All the vatos waiting for tomorrow

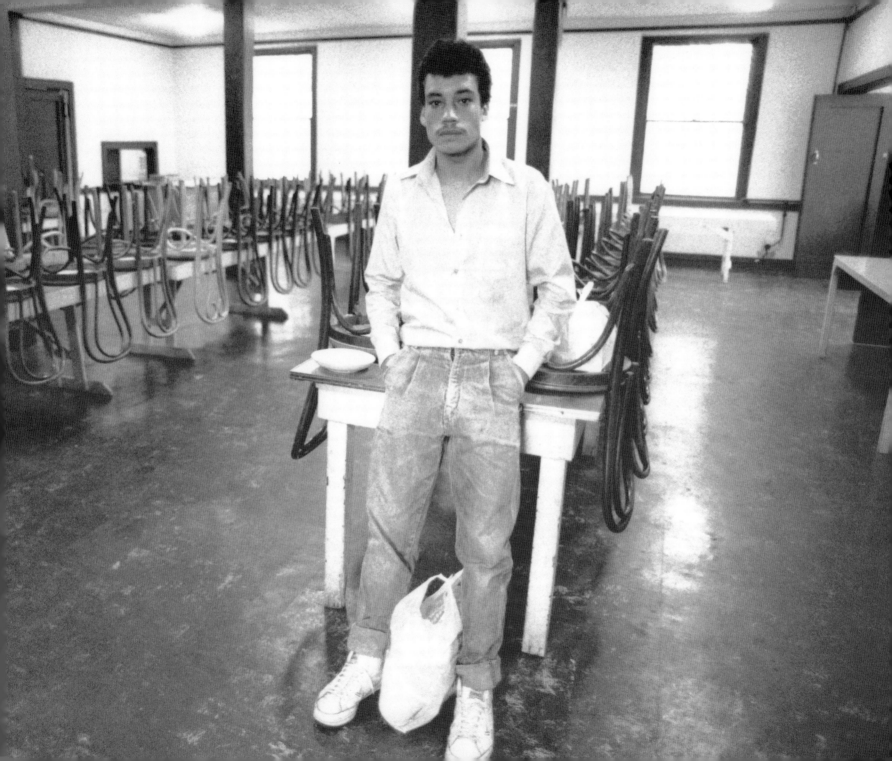

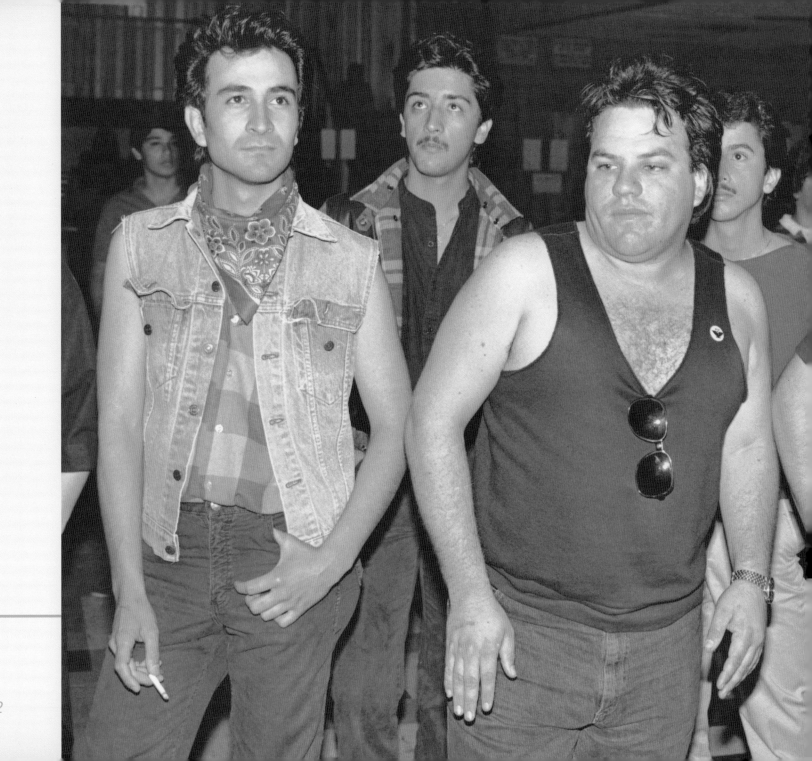

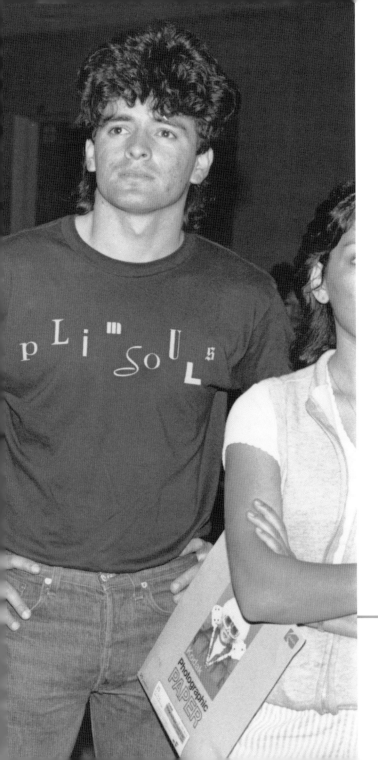

All the vatos sure that no one loves them

All the vatos sure that no one sees them

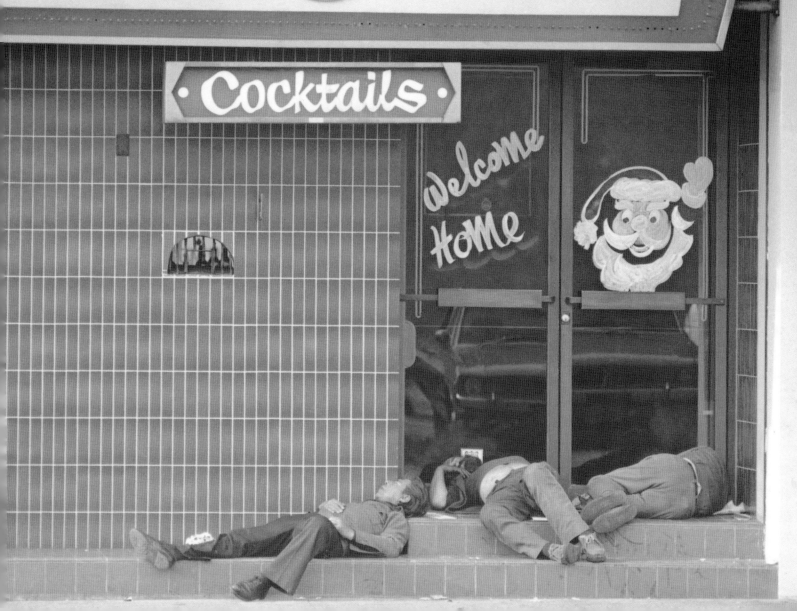

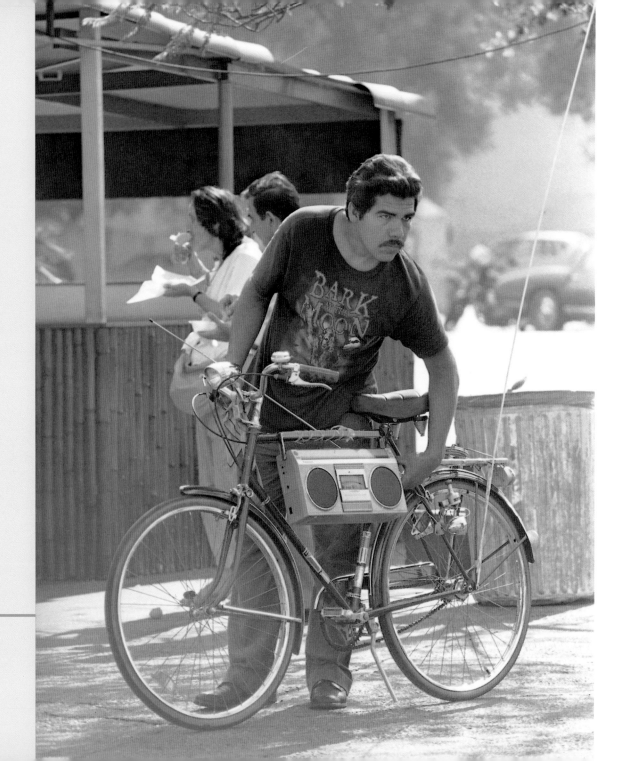

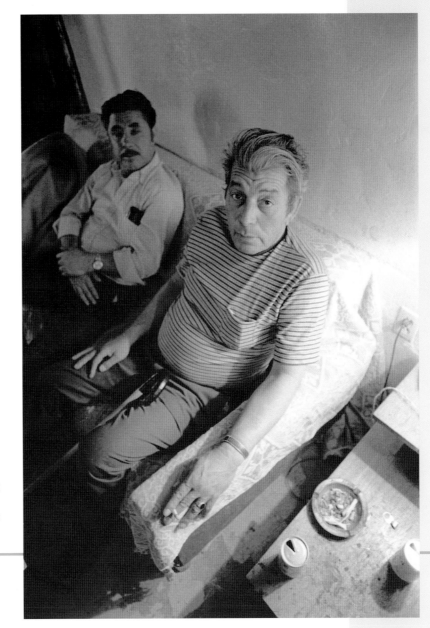

All the vatos sure that no one hears them

All the vatos never in a poem

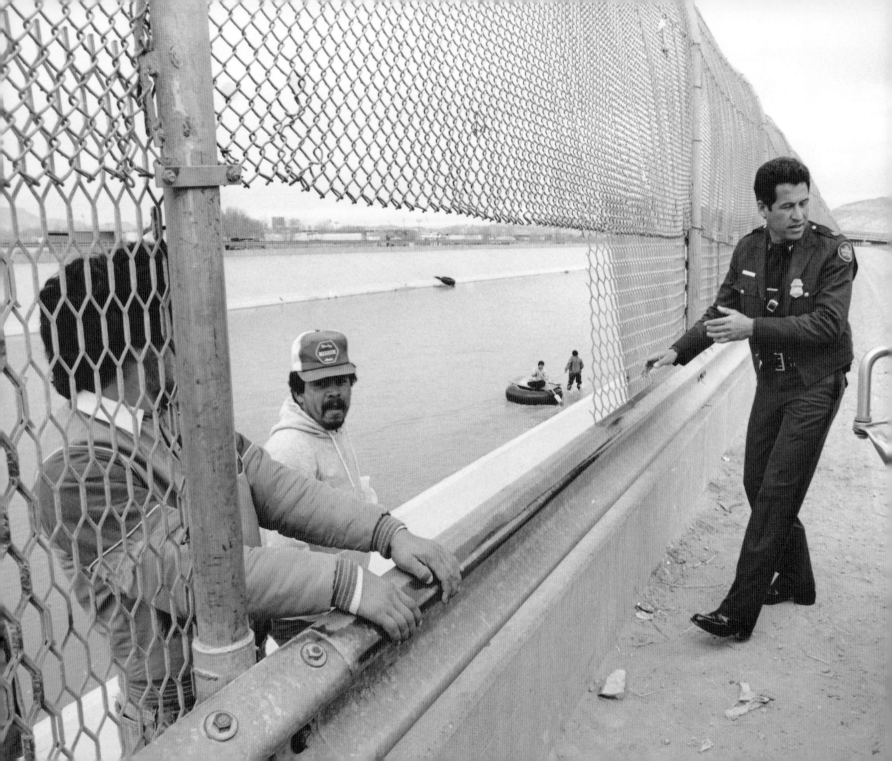

All the vatos told they don't belong here

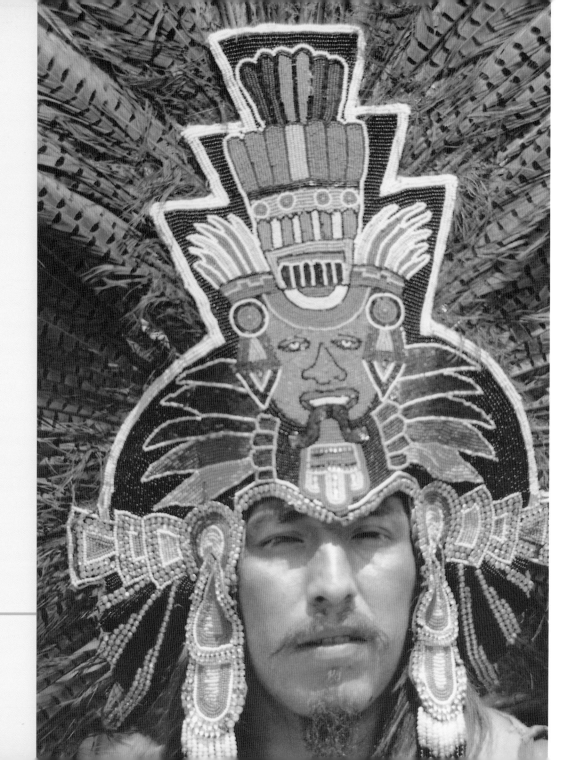

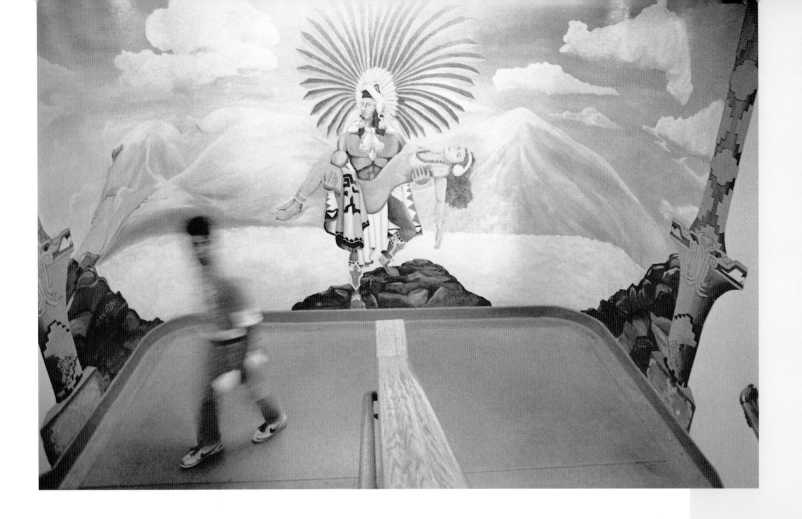

All the vatos beautiful young Aztecs

All the vatos warrior Apaches

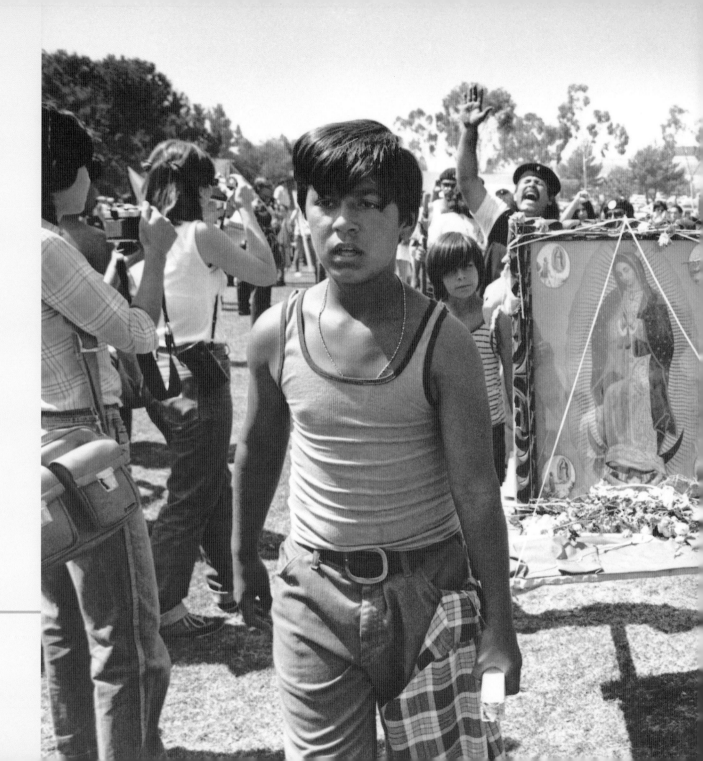

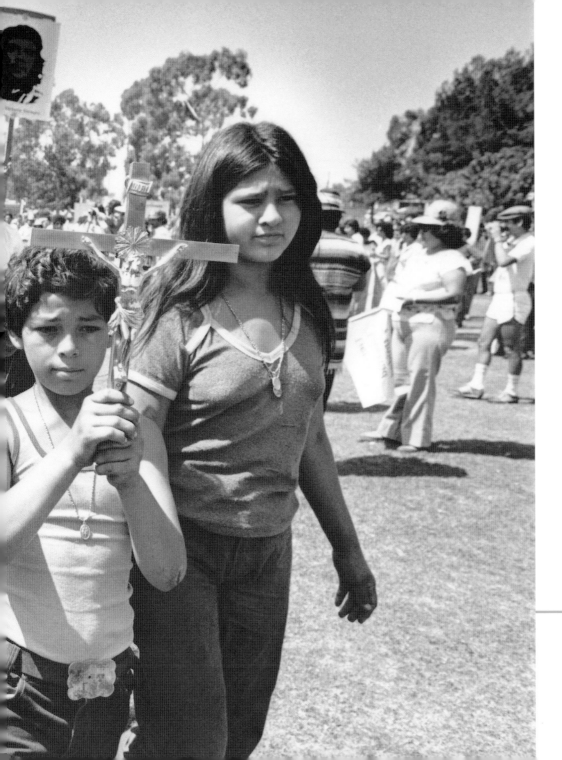

All the vatos sons of Guadalupe

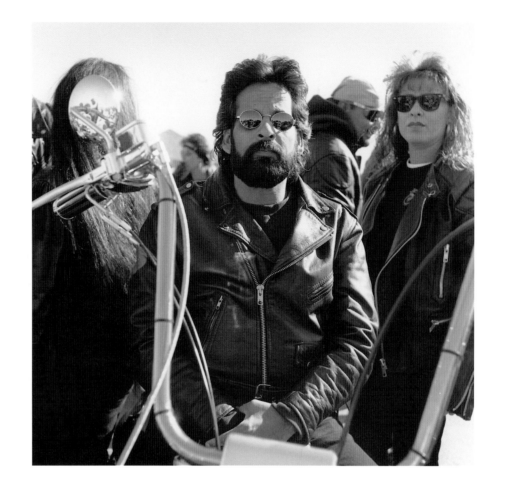

All the vatos bad as la chingada

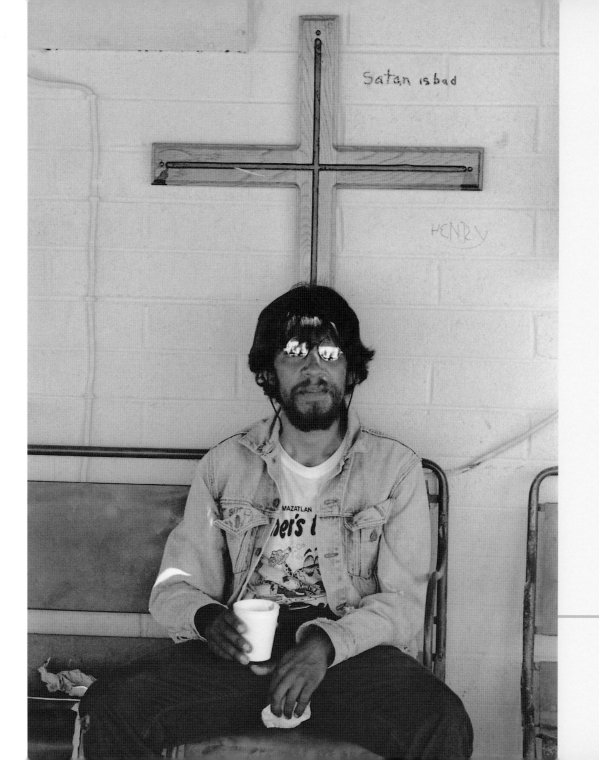

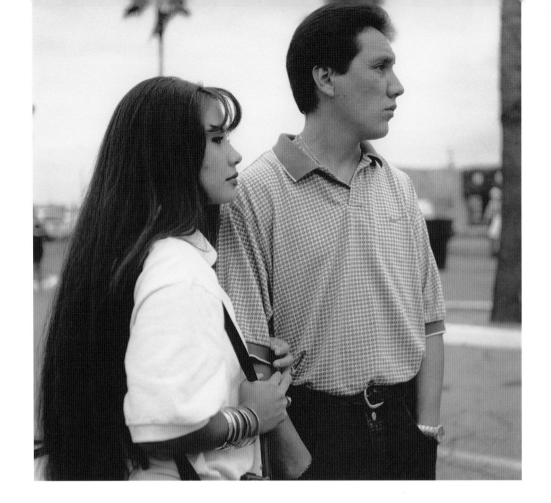

All the vatos call themselves Chicanos

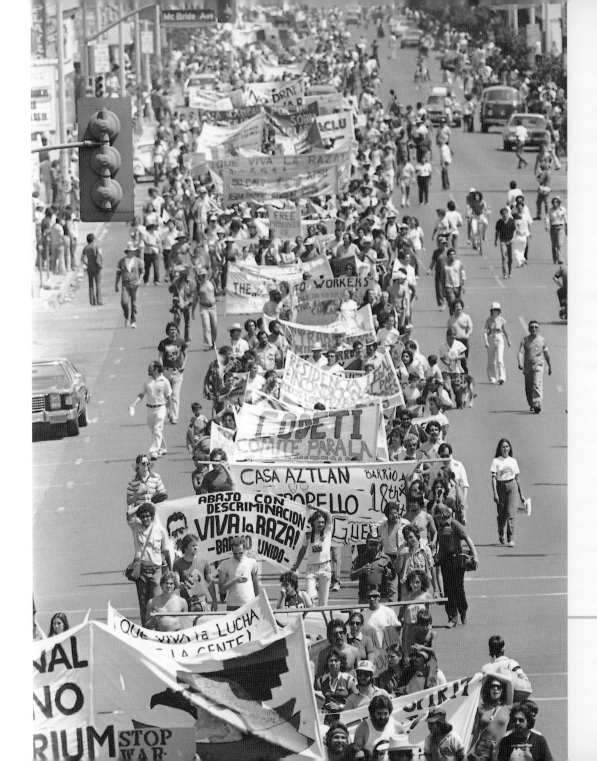

All the vatos praying for their children

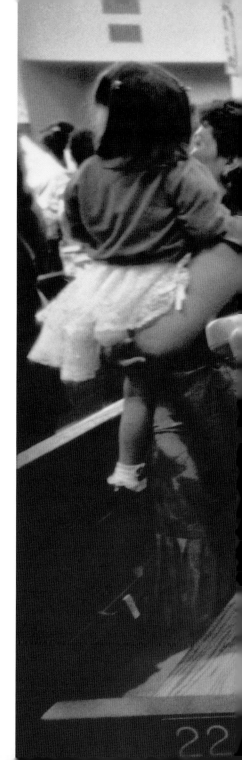

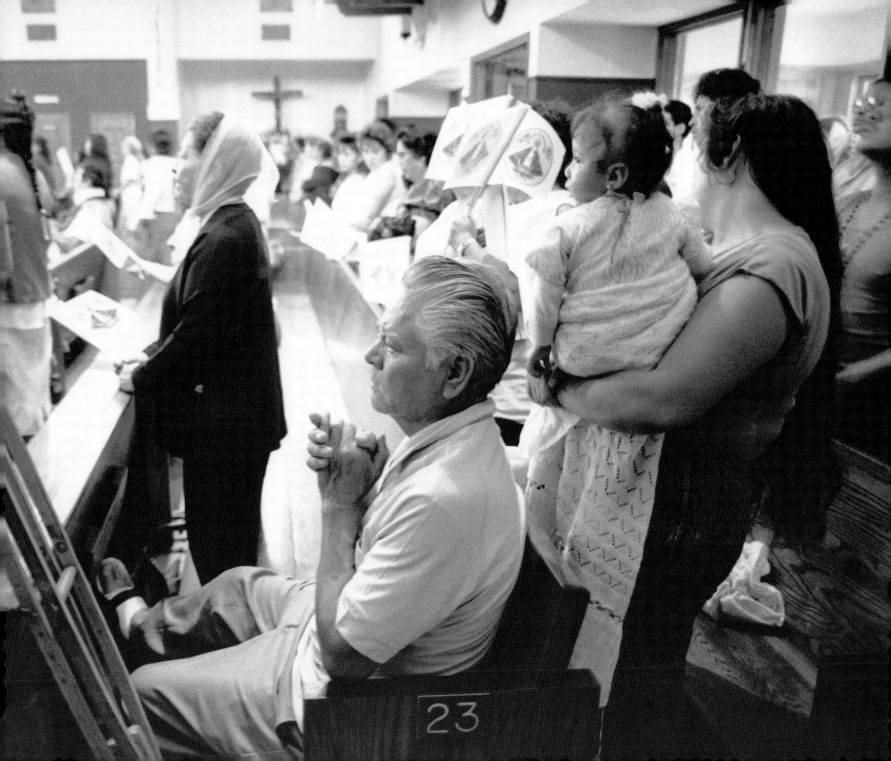

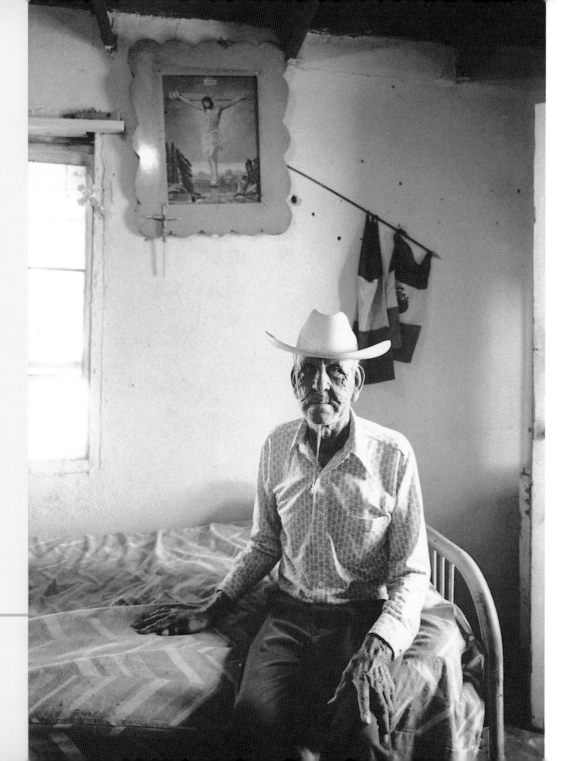

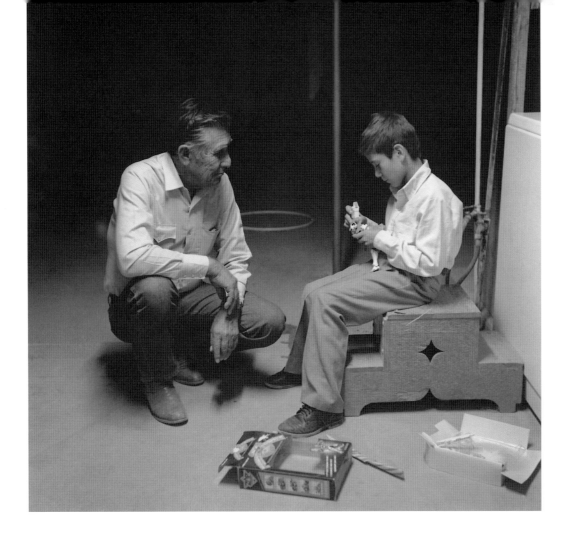

All the vatos even all you feos

All the vatos filled with life eternal

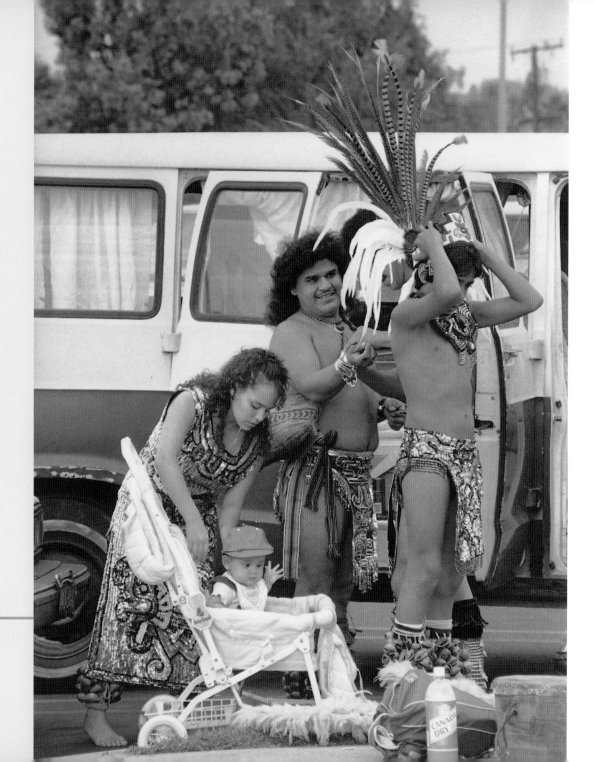

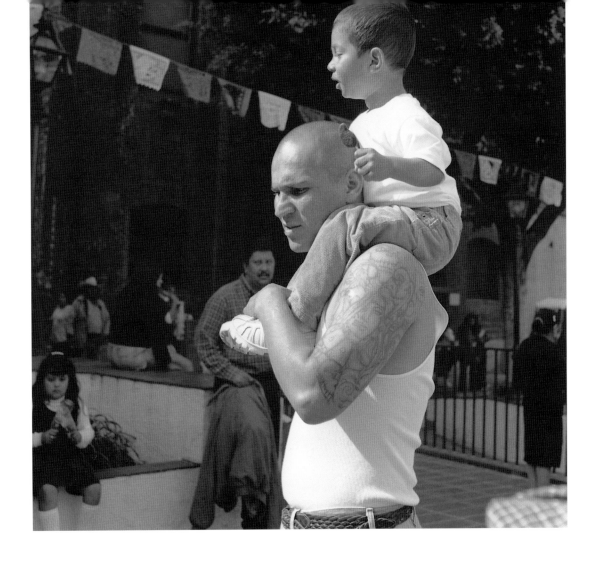

All the vatos sacred as the Sun God

All the vatos Flaco Pepe Gordo

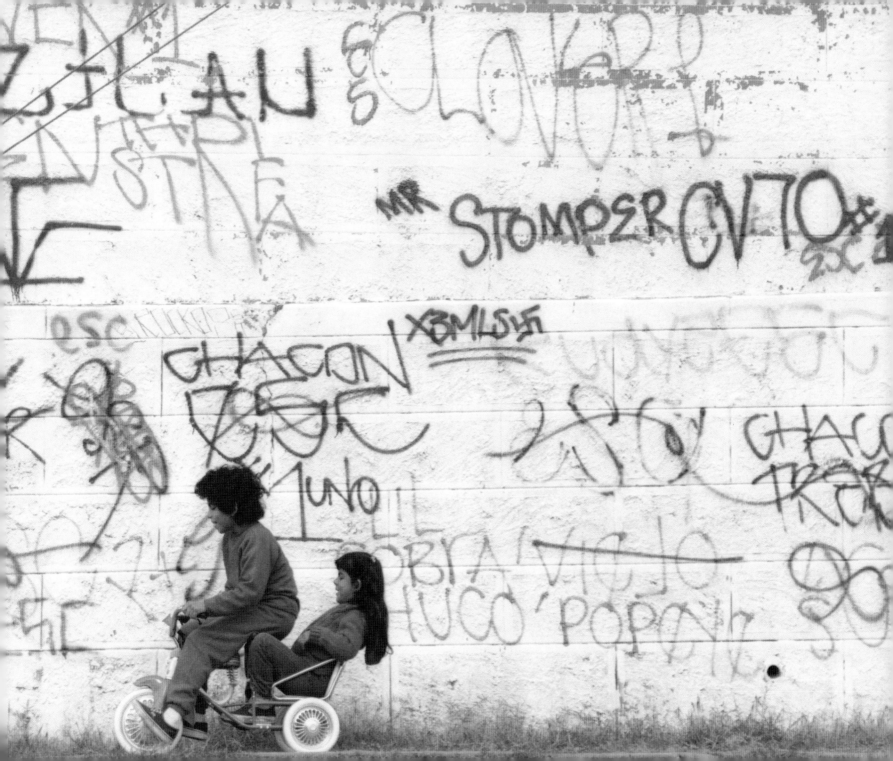

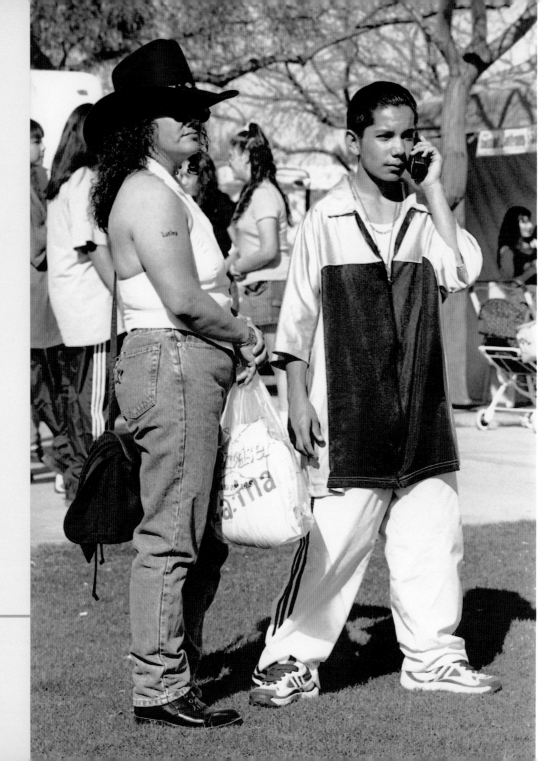

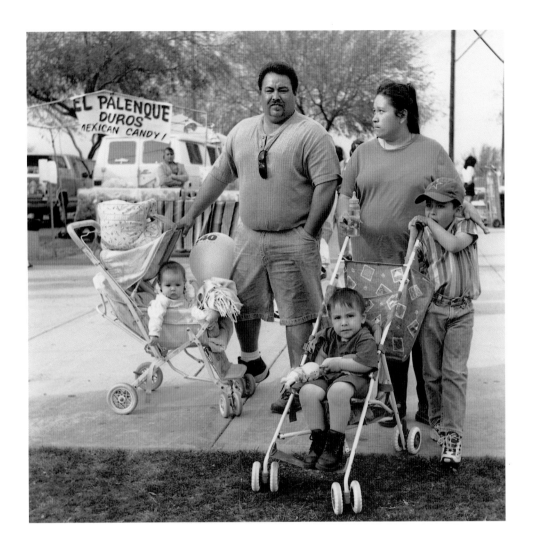

All the vatos rising from their mothers

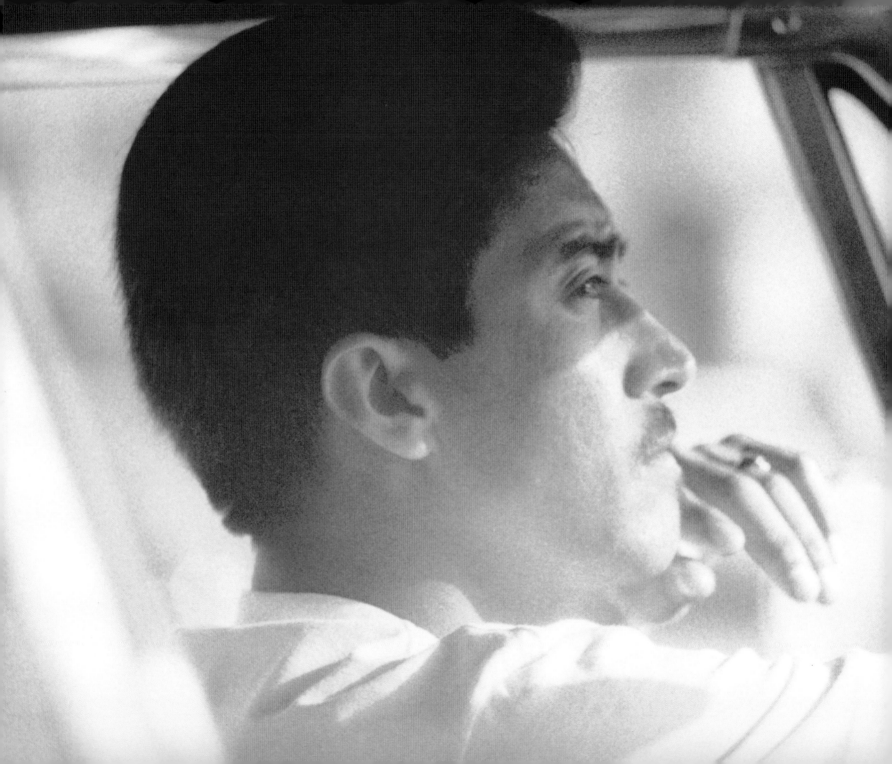

All you vatos, you are not forgotten.

photo captions

Cover & page 8. **Boyle Heights**, 1983
Man with daughter and friends in front of his house in the Boyle Heights neighborhood of Los Angeles.

Title page. **Two generations**, 1983
Raul (Yogie) Alaniz tying a bandanna on a younger boy. Yogie was the leader of the White Fence gang at the time of the photograph, which was taken in Boyle Heights, Los Angeles.

Page 6. **Boy in black shirt**, 1993
Taken during a community festival of different cultures in Tucson.

Page 10. **In the avocado groves**, 1982
Migrant workers in their tent in the avocado groves of San Diego County.

Page 13. **Making tortillas**, 1969
My tía, Mercy Montano, making tortillas for her son Junior at her house in Tucson.

Page 14. **Olvera Street**, 1999
Trio of vatos in their baggies—the style of choice for the '90s—on Cinco de Mayo in Los Angeles.

Page 15. **Hollenbeck Park**, 1983
Three vatos at an outdoor event in Los Angeles wearing the style of the '80s—shirts hanging out and buttoned from the top down.

Page 16. **El Super Chido**, 1990
Broadway Street in downtown LA during the Los Angeles Street Scene Festival with the historic Million Dollar Theater in the background. *Chido* is a barrio slang term loosely translated as cool, macho, bad, kick-ass.

Page 17. **Tattoos**, 1985
Vatos showing off their bodies and tattoos in East LA.

Page 18. **Raul (Yogie) Alaniz**, 1983.
At the time, Raul was the leader of the White Fence gang in Boyle Heights, Los Angeles.

Page 20. **Car-hopping competition**, 1990
This car-hopping competition was held during a low-rider car-blessing event in the Highland Park neighborhood of Los Angeles.

Page 22. **Young boy and old man**, 1970
These two subjects in Tucson showed a big difference in attitude about having their picture taken.

Page 24. **Father and daughter**, 1988
At a family picnic in the park after a daughter's first communion, Lincoln Heights, Los Angeles.

Page 25. **Banda festival**, 1998
Watching the dancers at a banda festival in Tucson.

Page 27. **Listening close**, 1986
Listening close to her, Los Angeles.

Page 28. **Vato**, 1984
Vato in a park in East LA.

Page 29. **Hair net**, 1999
Vato in a Tucson park, sporting a hair net.

Page 30. **Sleeping it off**, 1987
Taken during a "Los Lobos" concert in Lincoln Park, Los Angeles.

Page 31. **Singing along**, 1983
Singing along with the mariachis at El Mercado in East LA.

Page 32. **Street scene**, late '80s
Group of men during the Los Angeles Street Scene Festival.

Page 33. **Crying for a friend**, 1990
Crying at a friend's funeral in Montebello, California. The friend was the victim of a drive-by shooting.

Page 35. **Walking on by**, early '80s
Young men being stopped for questioning in East LA as woman skirts around them.

Page 36. **Harvesting asparagus**, 1986
Farm worker harvesting asparagus in Imperial County, California.

Page 37. **Military veteran**, 1989
Military veteran holding his daughter during a parade in Los Angeles.

Page 38. **Tattooing**, 1994
Youth tattooing his hand during a counseling session, Tucson.

Page 39. **Fingers**, 1983
Tattoos adorn fingers of high school kid at Garfield High School in East LA.

Page 40. **Viejos**, 1986
Older Latinos waiting for Mexican Independence Day celebrations to begin in Los Angeles.

Page 42. **Grandfather**, 1984
Grandfather holding a sleeping child during a wedding reception in Boyle Heights, Los Angeles.

Page 43. **Illustrated man**, 1987
The Chicano version of the Illustrated Man at Cinco de Mayo festivities in Lincoln Park, Los Angeles.

Page 44. **Early morning**, 1985
Farm worker on the bus before heading out to the campos in Calixico, California.

Page 45. **Suits**, 1991
Politico types during a press conference in Los Angeles.

Page 47. **Altar boys**, 1986
Día de Guadalupe celebration in Los Angeles.

photo captions

Page 49. **Outside church**, 1983
Young man standing outside of church during services in San Fernando, California.

Page 50. **Heading out**, 1983
Members of the White Fence gang heading out for the evening in Boyle Heights, Los Angeles.

Page 52. **Watching and waiting**, 1999
Teens watching people arrive at Kennedy Park, the main venue for Latino celebrations in Tucson.

Page 53. **Two in the hand**, 1992
Drinking a beer with the second ready to go, Tucson.

Page 54. **Faraway look**, 1999
Woman dancing with a faraway look during a banda festival in Tucson.

Page 55. **Holding on**, 1999
Woman keeping a hold on her dress during a banda festival in Tucson.

Page 57. **Resting in the shade**, 1999
Resting during a Cinco de Mayo celebration on Olvera Street in Los Angeles.

Page 58. **In the city**, 1999
Newcomers finding their way in Los Angeles.

Page 59. **In the hills**, 1982
Campesinos in the hills outside of San Diego sorting through clothes donated by church groups.

Page 61. **Waiting for lunch**, 1987
Homeless man in a church waiting for lunch in Long Beach, California.

Page 62. **Listening to music**, 1982
Early Chicano punkers listening to "Los Illegals" at an East LA college event.

Page 65. **Welcome home**, 1986
Passed out in a restaurant doorway in Los Angeles during the Christmas season.

Page 66. **Bicycle stereo**, 1988
This man in Los Angeles had come up with his own version of a bicycle stereo.

Page 67. **Uncle Geraldo**, late '60s
Uncle Geraldo Galvez visiting my Aunt Mercy in Tucson.

Page 68. **Hole in the fence**, mid-'80s.
Border patrol agent manning a hole in the fence as a man pulls others across the Rio Grande. Taken in El Paso at the border between Mexico and the United States.

Page 70. **Aztec dancer**, early '80s
Aztec dancer in a parade in East LA.

Page 71. **Garfield High School**, 1983
A hallway with an Aztec mural at Garfield High School in East LA.

Page 72. **La Virgen**, 1990
Kids carrying an altar of La Virgen de Guadalupe during a demonstration in Los Angeles.

Page 74. **Biker**, 1999
Man on his bike during the Biker Ride for Tots on Christmas Day in Tucson. He said his name was "Cheech."

Page 75. **Satan is bad**, 1989
Homeless man underneath a cross at a homeless center in Tucson.

Page 76. **Watchers**, 1999
Chicano couple at a Norteño Festival in South Tucson, Arizona.

Page 77. **Marching**, 1980
Ten-year anniversary march of the Chicano Moratorium in East LA.

Page 79. **Praying**, early '80s
Man praying in church on Olvera Street in Los Angeles.

Page 80. **Don Marcos Romero**, 1978
A photo of Don Marcos Romero, aka El Charro Negro, taken in Tucson. He rode with Pancho Villa.

Page 81. **Christmas**, 1995.
Roberto Lopez watches as young Carlos Moreno unwraps a Christmas present at my brother Bob's house in Tucson.

Page 82. **Getting ready**, 1990
Men dressing as Aztec dancers for the 20-year anniversary march of the Chicano moratorium in East LA.

Page 83. **Sitting tall**, 1999
Boy on father's shoulders during Cinco de Mayo festivities in Olvera Street, Los Angeles.

Page 85. **Graffiti**, early '80s.
Kids tricycling past graffiti-filled wall in Lincoln Heights, Los Angeles.

Page 86. **On the phone**, 1998
Teen on cell phone next to his mother at music event in Kennedy Park, Tucson.

Page 87. **Tex Mex Jam**, 2000
Family at a Tex Mex Jam in Kennedy Park, Tucson.

Page 88. **Lost in thought**, early '80s
Stopped at a traffic light in Los Angeles.

Page 94. **Self-portrait**, 1998
José Galvez at Pat's Chili Dog in Barrio Hollywood, Tucson, where he was born.

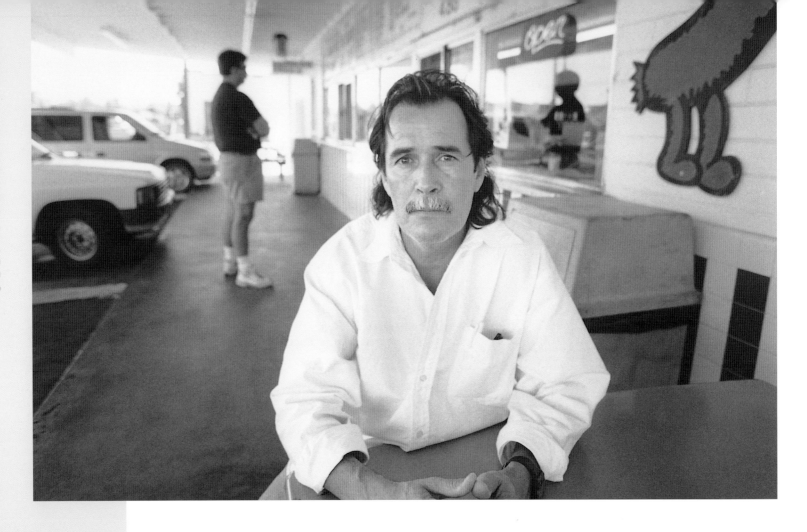

THESE PHOTOGRAPHS arise from my sense of responsibility to my family, my community and my culture. Since I began my career as a photographer, I have seen tremendous change. I have seen the barrios torn down and rebuilt into community centers and condos. I have seen campesinos from Mexico go from wearing huaraches to Nikes and Dallas Cowboy baseball caps. But one thing has been a constant in the Latino community—respect for family and for heritage. This is my culture, a culture that I am deeply proud of.

—JOSÉ GALVEZ

JOSÉ GALVEZ was lead photographer of a *L.A. Times* team that received a Pulitzer Prize for their stunning portrayal of Latinos in Southern Californa—the first Chicanos to receive a Pulitzer. For more than 30 years, Galvez has been documenting his own Mexican-American culture through photographs. Besides working as a staff photographer for the *Times* and other papers, he has done much freelance photojournalism and has contributed photos to the book *Americanos* produced by Edward James Olmos. He lives in Tucson with his wife Anne.

LUIS ALBERTO URREA was named by *Bloomsbury Review* as one of its "10 Young Writers to Watch." His book *Across the Wire*, which depicts life at the edges of the dumps in Tijuana, is in its 10th printing. A novelist, essayist and poet, he has received the Christopher Award, the Colorado Center for the Book Award, the Western States Book Award for Poetry, and the American Book Award, among others. With his wife Cindy and his family, he lives and teaches in Chicago.

I'M NOT ENTIRELY SURE how the Vatos poem came into being. I was working on this long thing called "The Tijuana Book of the Dead," which is a symbolic journey of the Mexican soul from birth to death and beyond. It is largely concerned with the fate of the family, or the mothers and fathers. And I had also been working on my novel about Teresita Urrea, the Saint of Cabora. I was absorbing a lot of female history and energy. Historically, I knew, women had been ignored and erased. But I suddenly realized that, outside of the historical record, the men were also ignored and erased. The modern Xicano/Mexicano/Latino man was invisible. And I thought: these poor men, nobody cares, nobody listens to them, nobody remembers them. My dad! My uncles! My brothers!

And I was thinking about Mexican churches, how you hear old women praying, that kind of rhythmic litany. And it all spilled out. Every line the exact same number of beats, as if 100 grandmas were praying to Guadalupe.

—LUIS URREA

PHOTO BY TERRI H. FENSEL

CINCO PUNTOS PRESS
EL PASO, TEXAS

IF YOU LIKED THIS BOOK, WE THINK YOU WILL ALSO ENJOY:

Six Kinds of Sky, A Collection of Short Fiction by Luis Alberto Urrea

Ghost Sickness, Poems by Luis Alberto Urrea

Frontera Dreams, A Héctor Belascoarán Shayne Detective Novel,
by Paco Ignacio Taibo II

Elegies in Blue, Poems by Benjamin Alire Sáenz

Puro Border, Dispatches, Snapshots, & Graffiti from the U.S. / Mexico Border,
edited by Luis Humberto Crosthwaite, John William Byrd and Bobby Byrd

The Late Great Mexican Border, Reports from a Disappearing Line,
edited by Bobby Byrd and Susannah Mississippi Byrd

FOR MORE INFORMATION, check out our website at **www.cincopuntos.com**
or give us a call at 800-566-9072 to receive a catalog.

—

Printed in Hong Kong by Morris Printing.

Book and cover design by Vicki Trego Hill of El Paso, Texas.